THAT IS PRICELESS

Art's Greatest Masterpieces . . .
Made Slightly Funnier

Steve Melcher

Andrews McMeel
Publishing, LLC
Kansas City • Sydney • London

For my wife,
Amanda

For your brilliant ideas and tireless hours
of work—and for your uncanny comedy instincts
that take all our projects to another level.
Without you, this book would
not have been possible.

11 12 13 14 15 WKT 10 9 8 7 6 5 4 3 2 1

ISBN: 978-1-4494-0248-8

Library of Congress Control Number: 2010930555

www.andrewsmcmeel.com

Attention: Schools and Businesses
Andrews McMeel books are available at quantity discounts with bulk purchase for educational,
business, or sales promotional use. For information, please write to: Special Sales Department,
Andrews McMeel Publishing, LLC, 1130 Walnut Street, Kansas City, Missouri 64106.

Contents

Acknowledgments . . . iv

The Inspiration . . . v

1. BRUSHES WITH FAME
Celebrities Caught on Canvas . . . 1

2. POP ART
Inspired by TV and Movies . . . 23

3. ART IN HEAVEN
Religious Themes . . . 45

4. THE BLUE PERIOD
Gratuitous Swearing and Sexual Content . . . 67

5. MASTERWORKS REWORKED
Artwork That's Been Tweaked by the Author . . . 91

6. STUDY IN LIGHT AND DARK
Darker Jokes for Those Who Take Their Humor Black . . . 103

7. THE ROMANTIC MOVEMENT
Paintings of Love . . . 121

8. MASTERS OF THEIR DOMAIN
Home Life . . . 137

9. ARTISTS AT WORK
Taking Care of Business . . . 159

10. THE ART OF THE GAME
Sports . . . 173

About the Author . . . 186

About the Type . . . 186

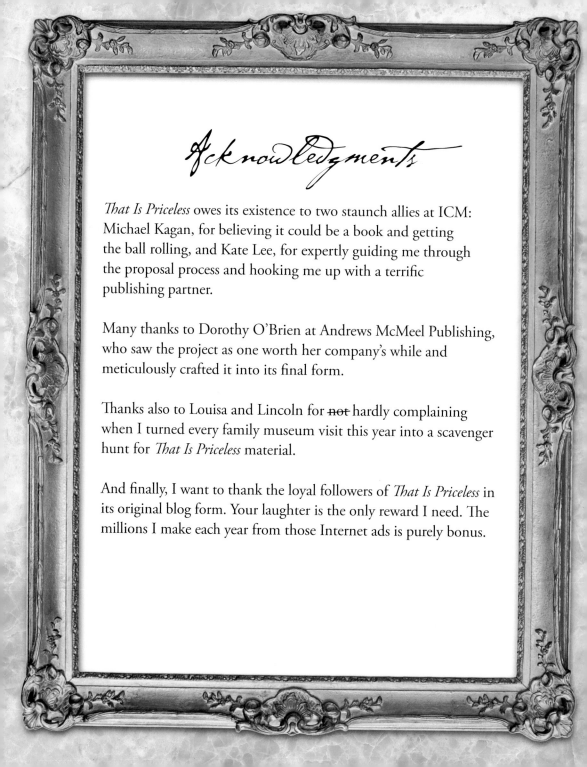

Acknowledgments

That Is Priceless owes its existence to two staunch allies at ICM: Michael Kagan, for believing it could be a book and getting the ball rolling, and Kate Lee, for expertly guiding me through the proposal process and hooking me up with a terrific publishing partner.

Many thanks to Dorothy O'Brien at Andrews McMeel Publishing, who saw the project as one worth her company's while and meticulously crafted it into its final form.

Thanks also to Louisa and Lincoln for ~~not~~ hardly complaining when I turned every family museum visit this year into a scavenger hunt for *That Is Priceless* material.

And finally, I want to thank the loyal followers of *That Is Priceless* in its original blog form. Your laughter is the only reward I need. The millions I make each year from those Internet ads is purely bonus.

The Inspiration

In November 2009, I was idly trolling the gift shop at the Norton Simon Museum, when I came upon a postcard for Peter Paul Rubens's *The Finding of Erichthonius*.

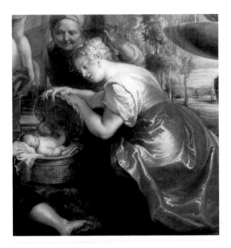

As with most art, I had no clue as to what was actually supposed to be going on in the painting. I mean, seriously—who the hell is Erichthonius? But suddenly, an alternate title popped into my head: *Worst Secret Santa Gift Ever*.

I scrambled for a Post-it note, and *That Is Priceless* was born.

BRUSHES WITH FAME

Celebrities Caught on Canvas

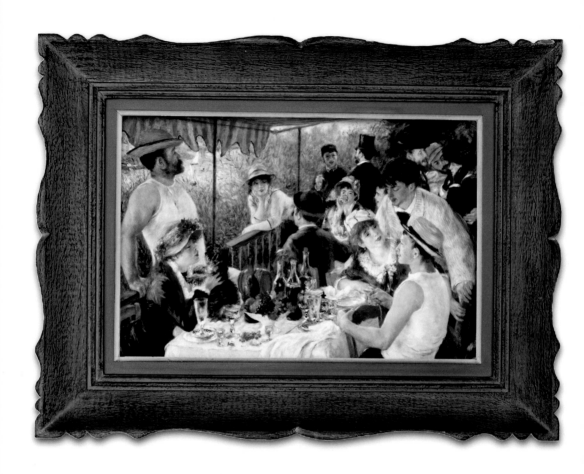

PIERRE-AUGUSTE RENOIR, FRENCH

*Lunch Break at Kid Rock
Look-Alike Contest,* 1881

Oil on canvas

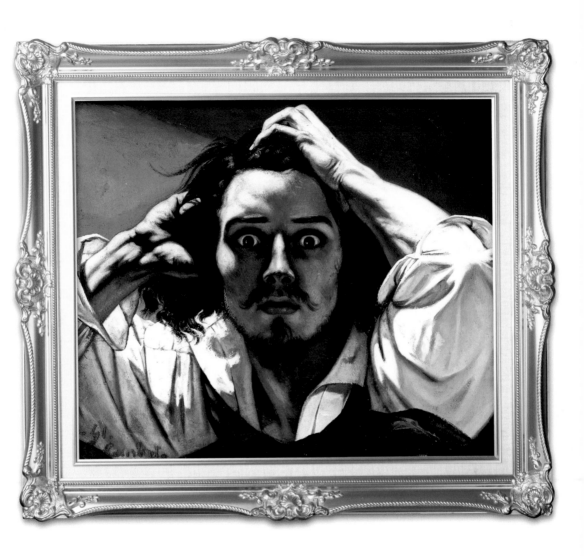

GUSTAVE COURBET, FRENCH
*Johnny Depp Realizing
He Left the Oven On*, 1844
Oil on canvas

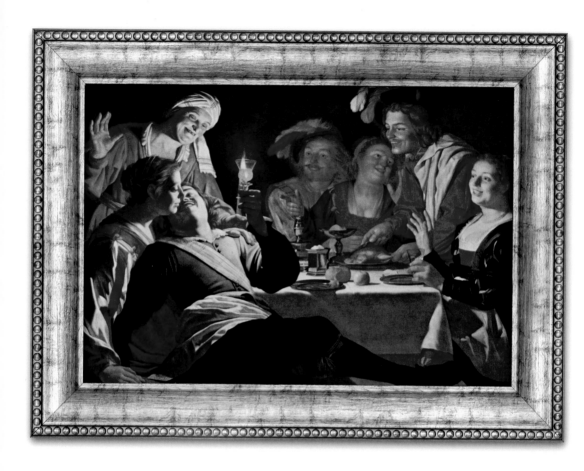

GERARD VAN HONTHORST, DUTCH

*Jack Black's Fortieth
Birthday Bash*, 1623

Oil on canvas

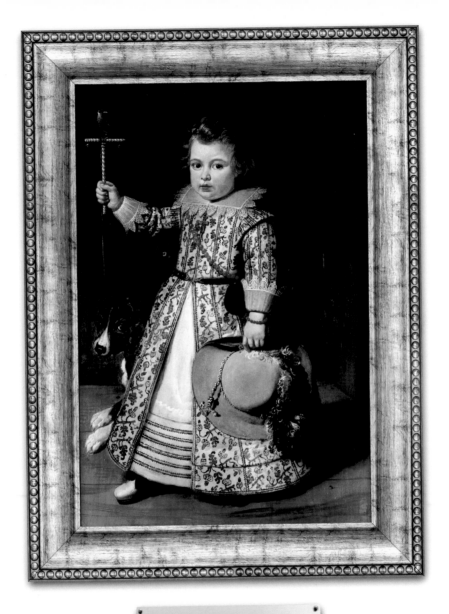

ARTIST UNKNOWN, FLEMISH SCHOOL

*Liberace's First Day
of Kindergarten*, 1934

Oil on panel

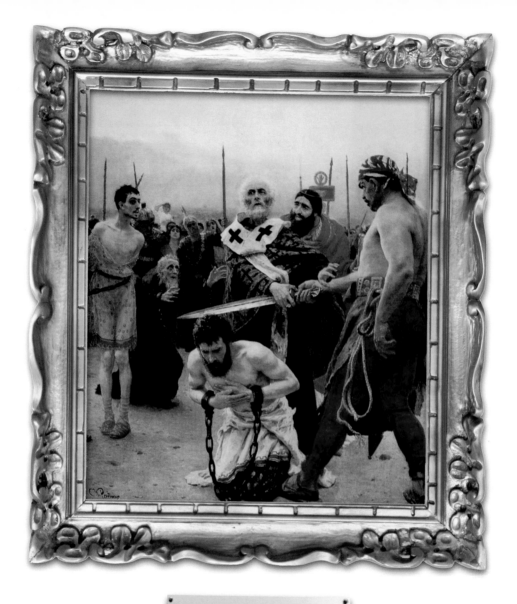

ILYA YEFIMOVICH REPIN, RUSSIAN

*Antonio Banderas Escaping
Execution by the Turks*, 1888

Oil on canvas

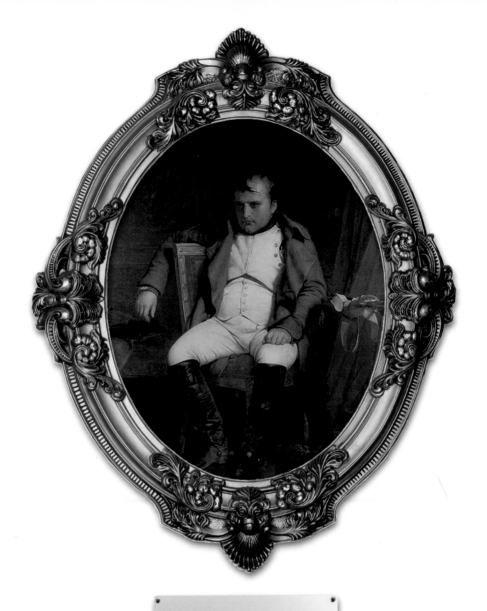

PAUL DELAROCHE, FRENCH
Napoleon Needs a Red Bull, 1845
Oil on canvas

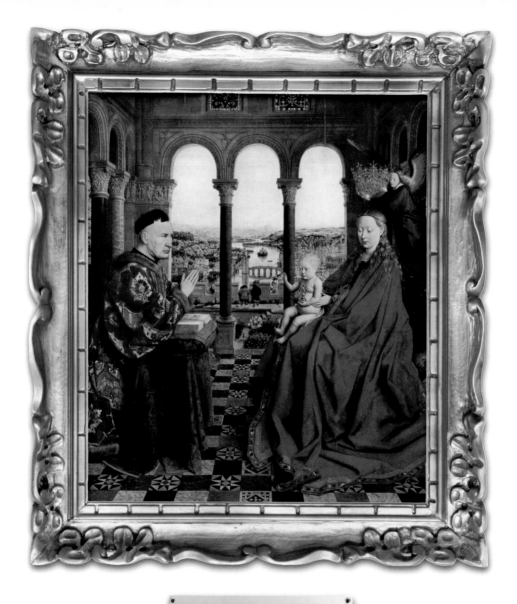

JAN VAN EYCK, FLEMISH

De Niro Begging Forgiveness for Eight of His Last Ten Movies, 1435

Oil on panel

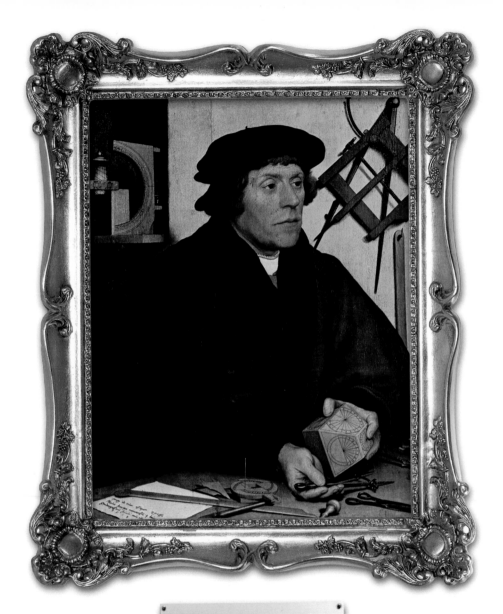

HANS HOLBEIN THE YOUNGER, GERMAN

*Frances McDormand
in "Copernicus,"* 1528

Tempera on wood

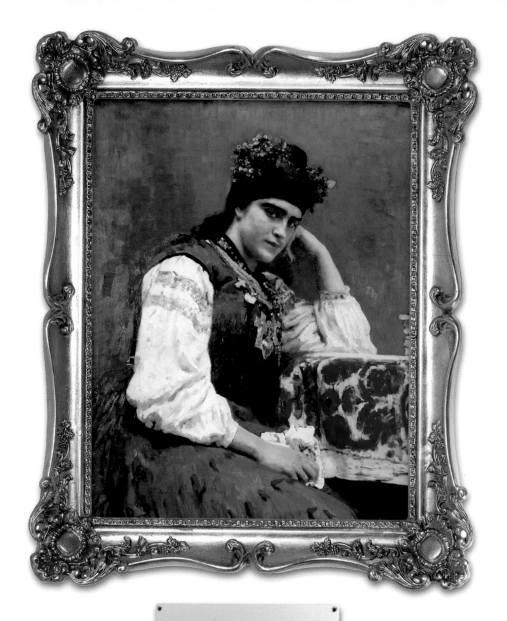

ILYA YEFIMOVICH REPIN, RUSSIAN
Joaquin Phoenix in "Frida 2," 1889
Oil on canvas

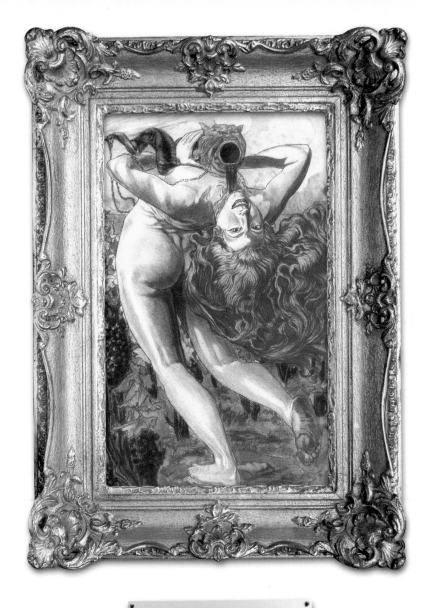

CARLOS SCHWABE, SWISS-GERMAN
*Lady Gaga's High School
Yearbook Photo*, 1907
Oil on canvas

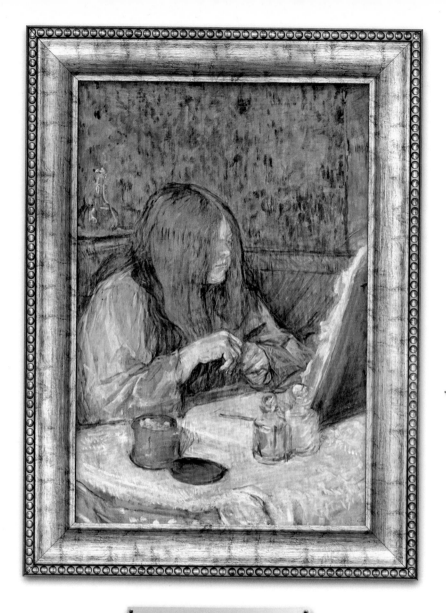

HENRI DE TOULOUSE-LAUTREC, FRENCH

*Janis Joplin Getting
Ready for Prom*, 1899

Oil on canvas

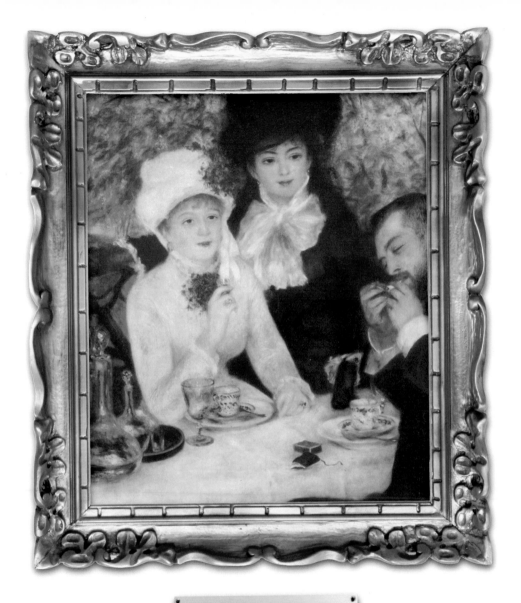

PIERRE-AUGUSTE RENOIR, FRENCH
*Jude Law Getting High
at Easter Brunch*, 1879
Oil on canvas

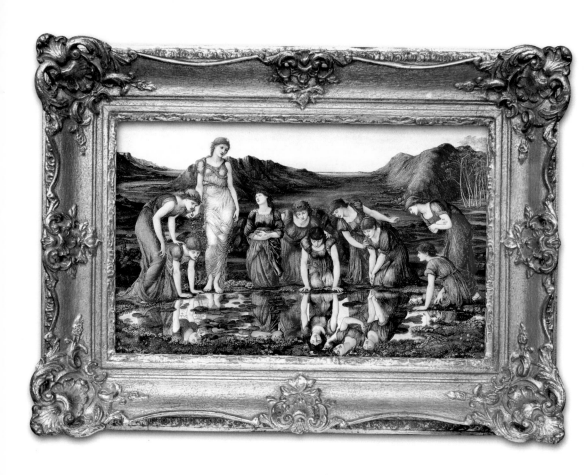

SIR EDWARD BURNE-JONES, ENGLISH
*Kate Moss Teaching Young Models
Proper Purging Technique*, 1875
Oil on canvas

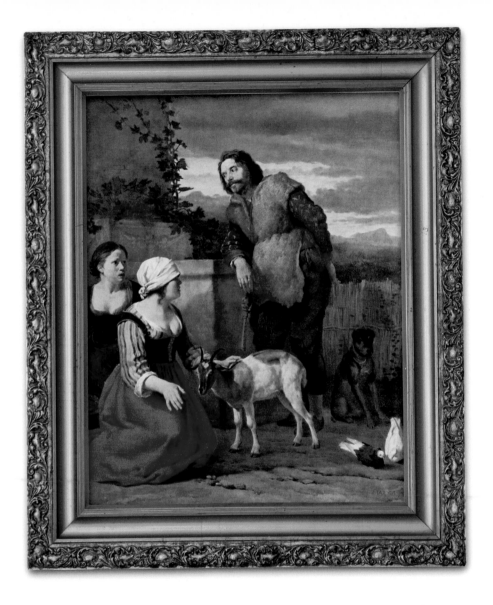

KAREL DUJARDIN, DUTCH
Charles Manson Hitting on Chicks,
1650
Oil on canvas

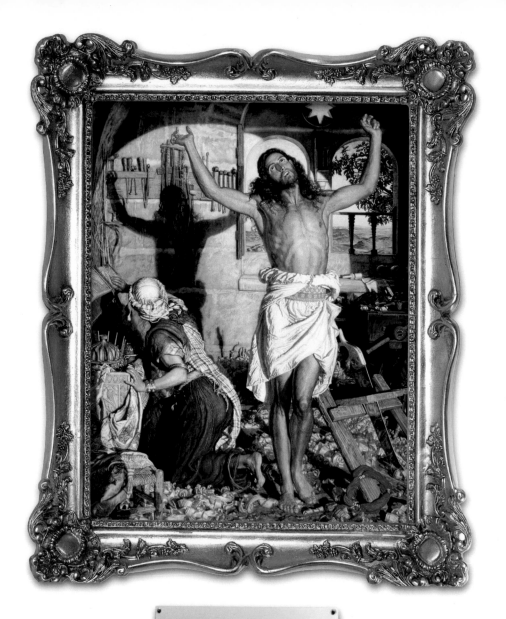

WILLIAM HOLMAN HUNT, ENGLISH
Matthew McConaughey
Off His Meds Again, 1870
Oil on canvas

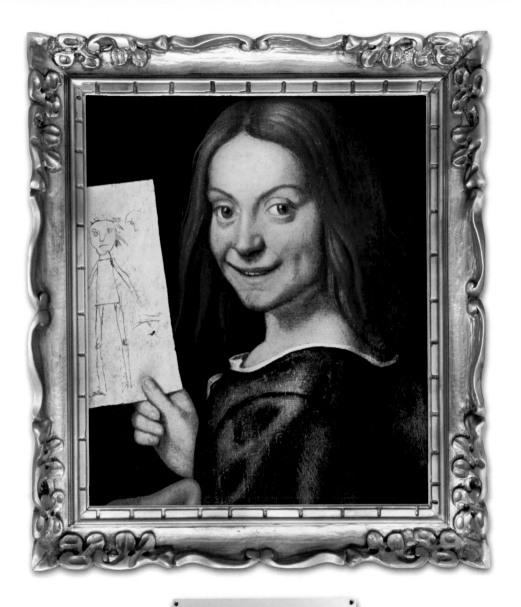

GIOVANNI FRANCESCO CAROTO, ITALIAN
Amy Poehler with Self-portrait, 1525
Oil on wood

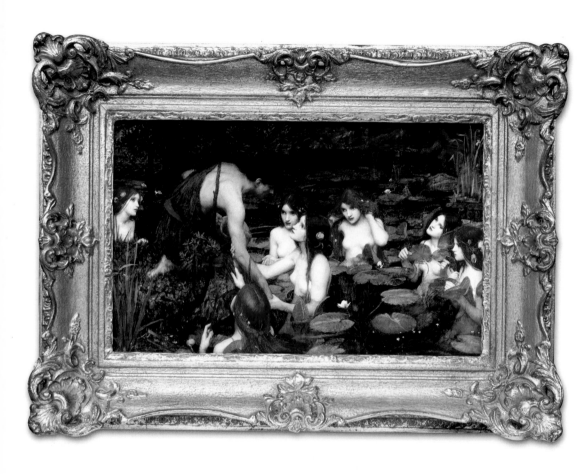

JOHN WILLIAM WATERHOUSE, ENGLISH
*Roman Polanski's
Version of Events*, 1896
Oil on canvas

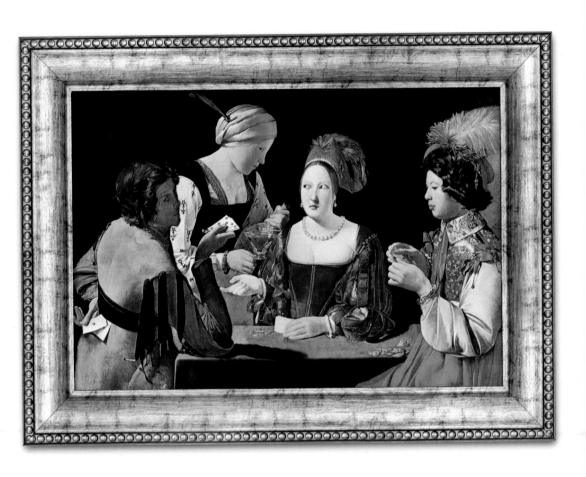

GEORGES DE LA TOUR, FRENCH
Rob Lowe, About to Get Busted for Cheating Again, 1635
Oil on canvas

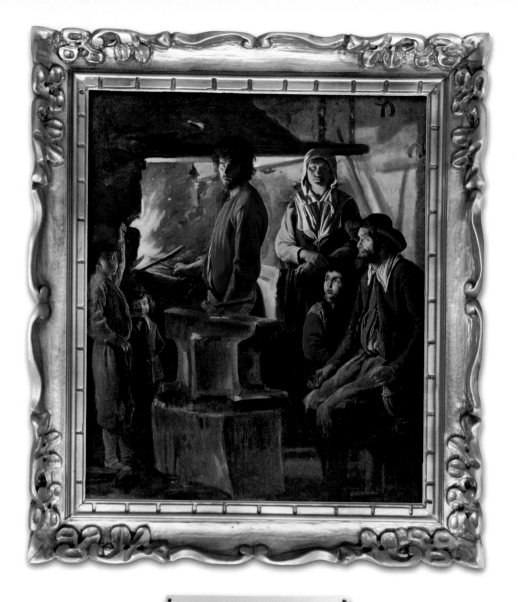

LOUIS LE NAIN, FRENCH

*Family Waiting to Be Seated at
Jim Morrison's Wood-fired Pizza,*
1625

Oil on canvas

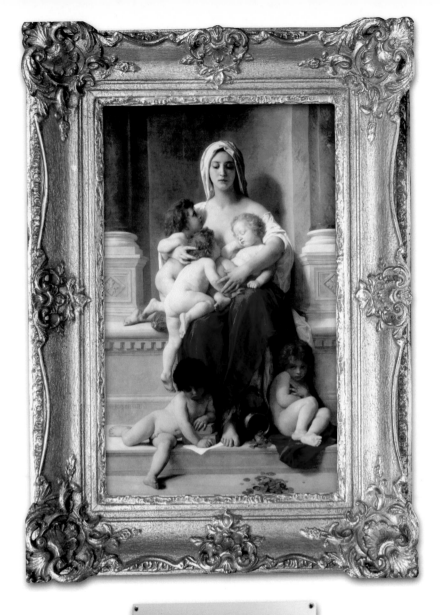

WILLIAM-ADOLPHE BOUGUEREAU, FRENCH

*Octomom Trying to Remember What
She Did with the Other Three*, 1878

Oil on canvas

POP ART

Inspired by TV and Movies

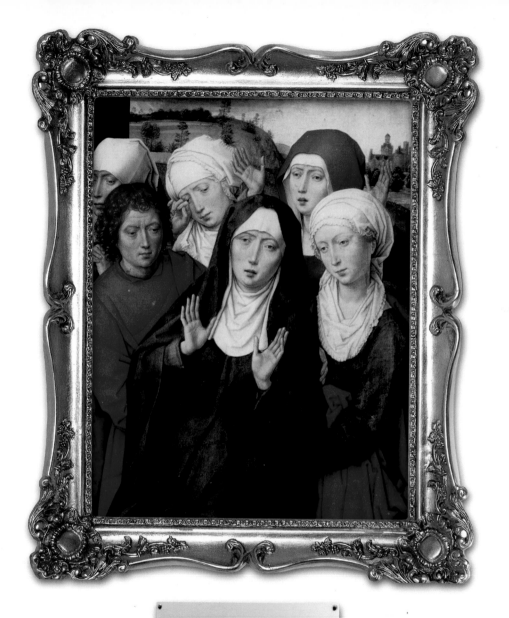

JUAN DE BORGOÑA, SPANISH
Virgin Mary Voted Off "Idol," 1515
Oil on canvas

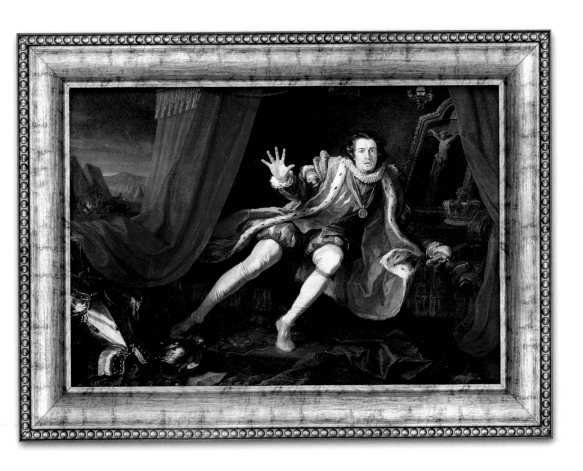

WILLIAM HOGARTH, ENGLISH
Richard III Accosted by Painter from TMZ, 1745
Oil on canvas

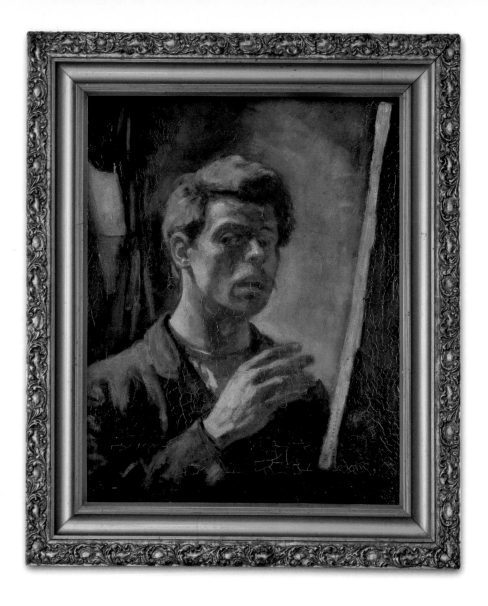

THEO VAN DOESBURG, DUTCH

The Artist, Realizing He Forgot to TiVo "Glee," 1906

Oil on canvas

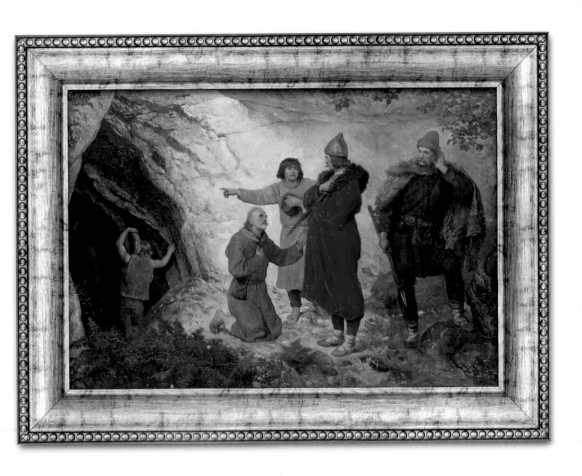

WOJCIECH GERSON, POLISH
*You've Gotta Tell That Bin Laden Guy
to Turn Down the Taylor Swift*, 1890
Oil on canvas

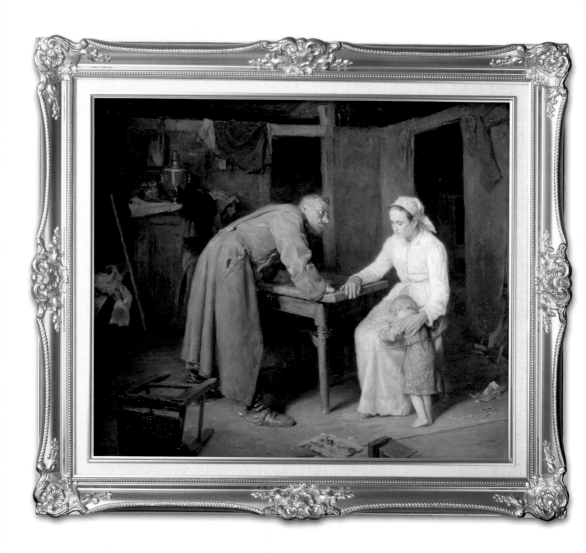

NIKOLAJ ALEXEJEWITSCH KASSATKIN,
RUSSIAN

*Jack Bauer Interrogating Suspect
on Russian Version of "24,"* 1897

Oil on canvas

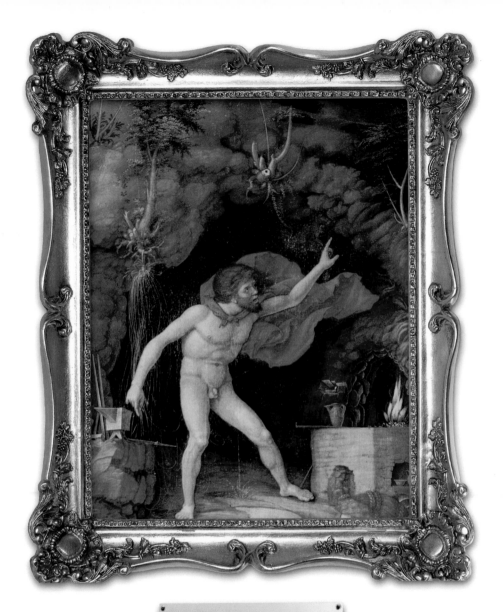

ANDREA MANTEGNA, ITALIAN
That Nutjob in the Cave Who Thinks He's Superman, 1497
Tempera on panel

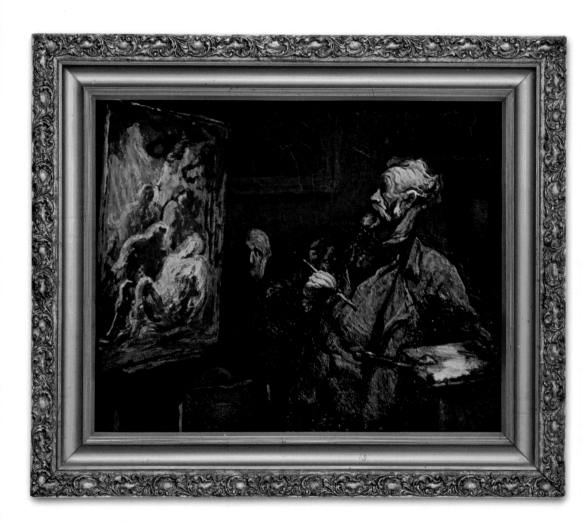

HONORÉ DAUMIER, FRENCH
*Auguste Renoir Gets Punk'd
(Talking Painting Gag)*, 1869
Oil on canvas

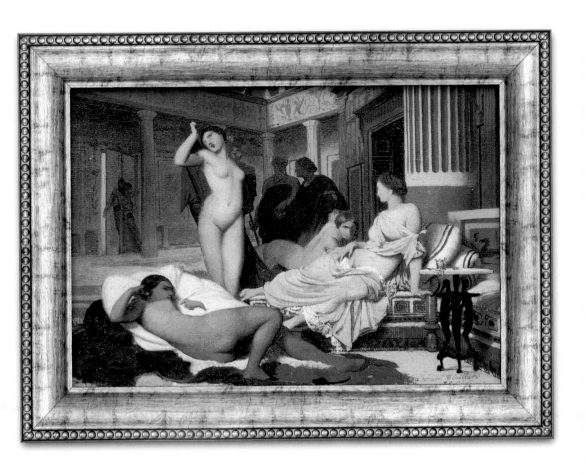

JEAN-LÉON GÉRÔME, FRENCH
Real Housewives of the Acropolis,
1860
Oil on canvas

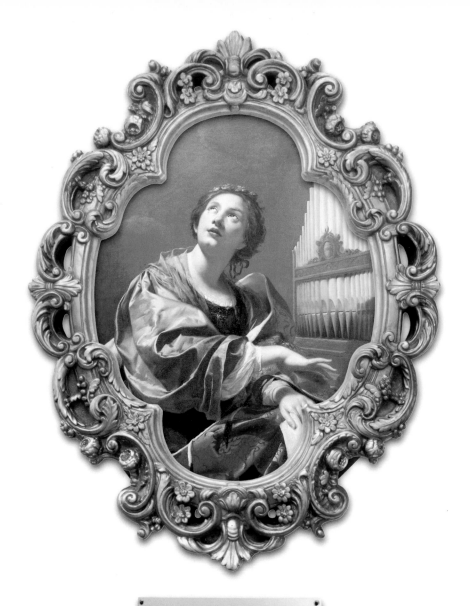

SIMON VOUET, FRENCH
*Organist Taking God's Request
for "Piano Man"...Again*, 1626
Oil on canvas

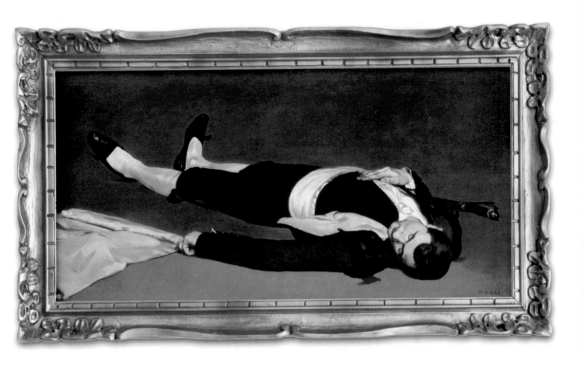

EDOUARD MANET, FRENCH
The Phantom of the Opera,
Killed While Folding Towels, 1864
Oil on canvas

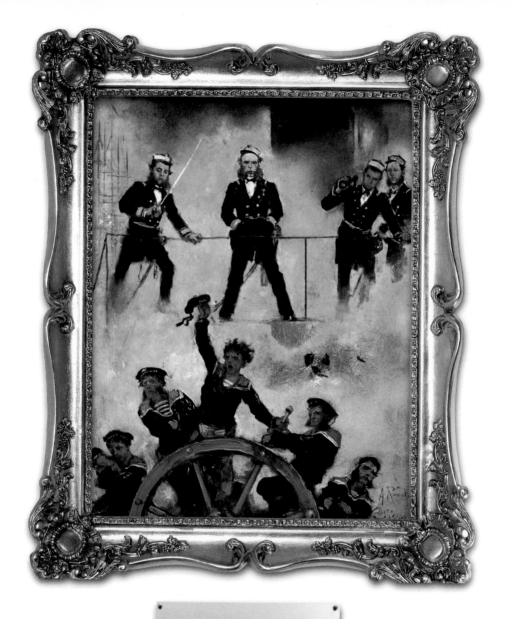

ANTON ROMAKO, AUSTRIAN
"Mutton Chops: The Musical," 1878
Oil on canvas

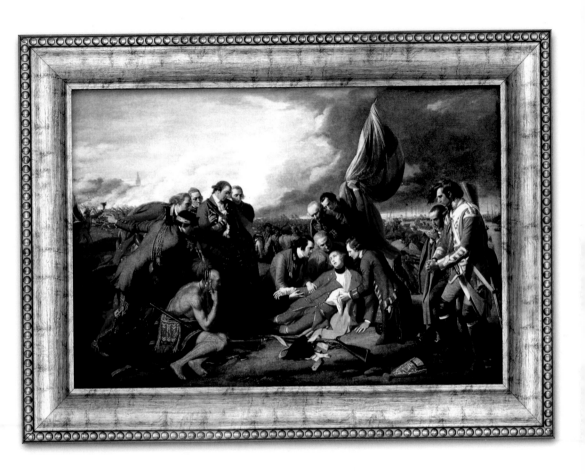

BENJAMIN WEST, AMERICAN
*General Wolfe Upon Learning He's
Won Justin Bieber Tickets*, 1770
Oil on canvas

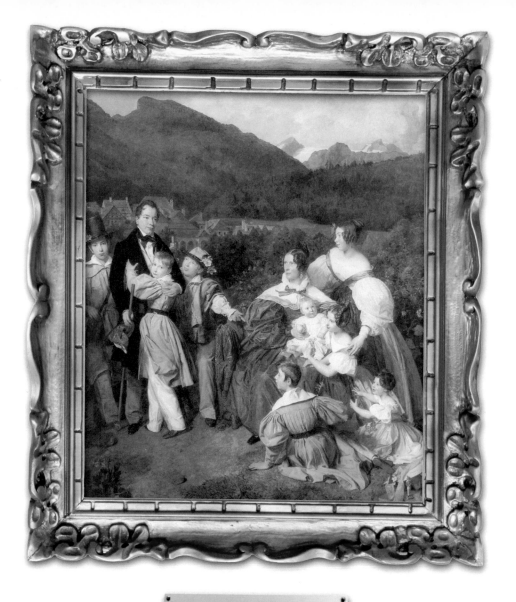

FERDINAND GEORG WALDMÜLLER,
AUSTRIAN
Johann and Katharine Plus VIII, 1835
Oil on canvas

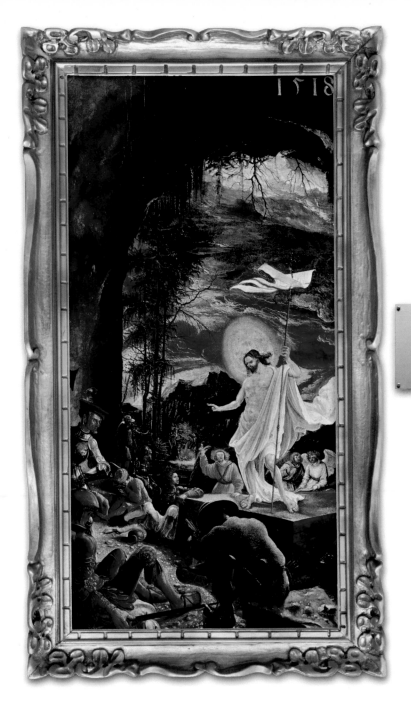

ALBRECHT ALTDORFER, GERMAN
Jesus as Himself in
"Jesus Christ Superstar,"
1518
Oil on panel

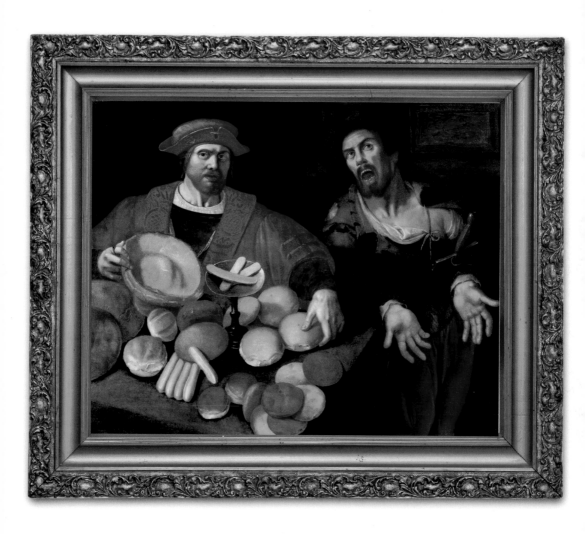

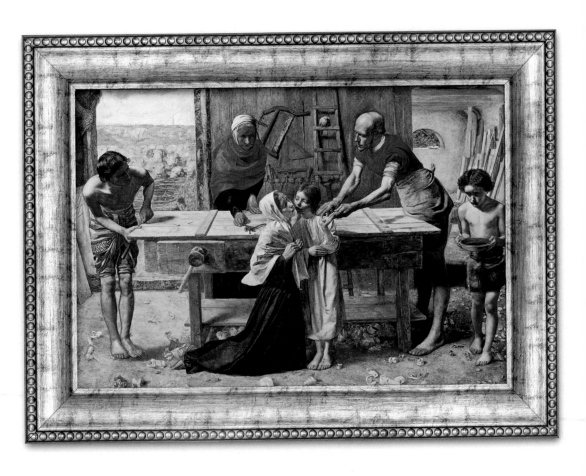

JOHN EVERETT MILLAIS, ENGLISH
Coming This Fall to CBS:
"Everybody Loves Jesus," 1850
Oil on canvas

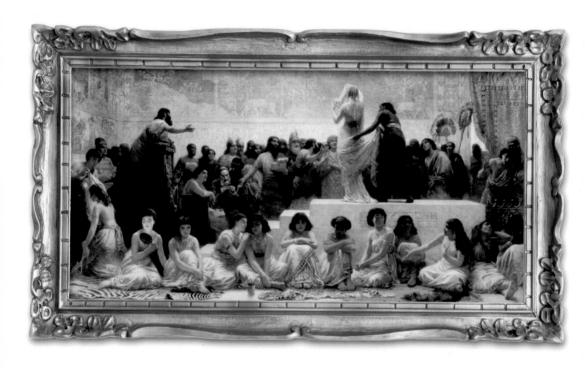

EDWIN LONG, ENGLISH

*Evening Gown Competition at the
Miss Teen Concubine Pageant,*
1875

Oil on canvas

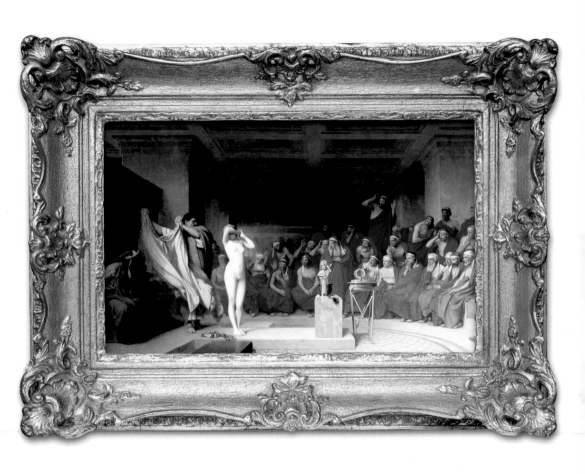

JEAN-LÉON GÉRÔME, FRENCH
*The Shocking Final Weigh-In on
"The Biggest Loser: Greece,"* 1861
Oil on canvas

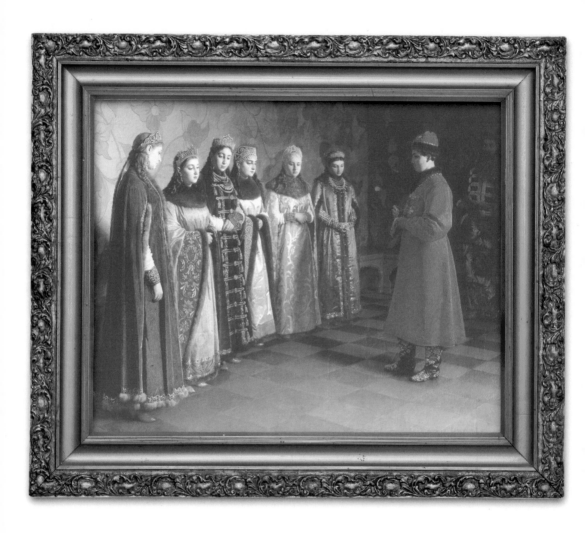

GRIGORY SEDOV, RUSSIAN
"The Bachelor: St. Petersburg," 1882
Oil on canvas

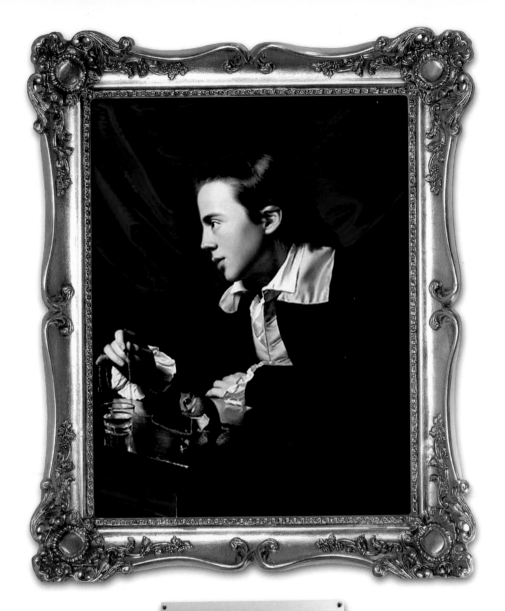

JOHN SINGLETON COPLEY, AMERICAN
"Alvin and the Chipmunks 3:
Chipmunks in Chains," 1765
Oil on canvas

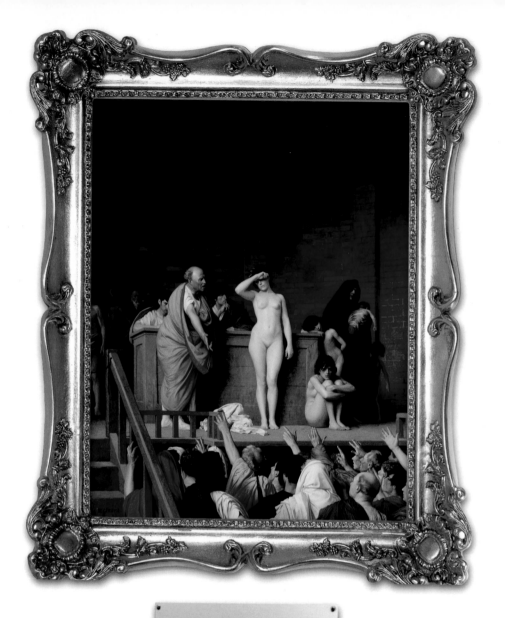

JEAN-LÉON GÉRÔME, FRENCH
*Season Finale of "Rome's
Next Top Household Slave,"* 1884
Oil on canvas

ART IN HEAVEN

Religious Themes

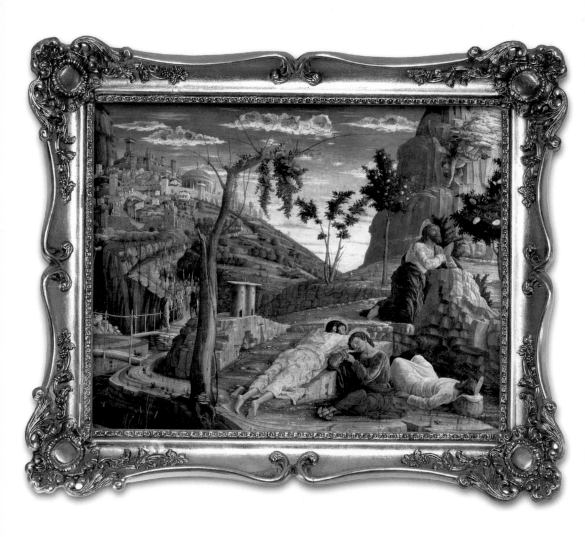

GIORGIO VASARI, ITALIAN
Angel Delivering an Ambien, 1570
Oil on canvas

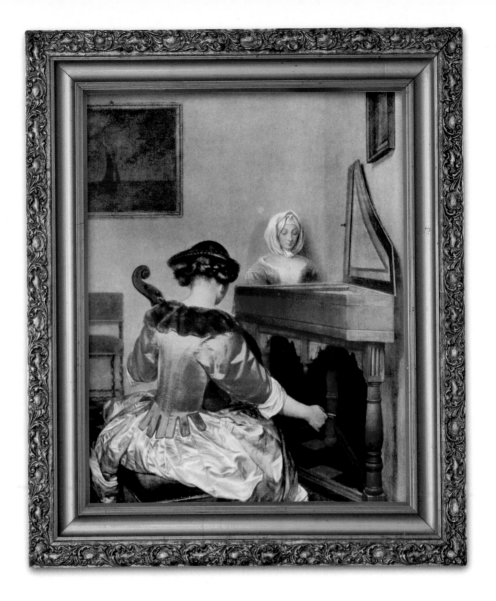

GERARD TER BORCH, DUTCH
*The Virgin Mary at
Band Practice*, 1655
Oil on wood

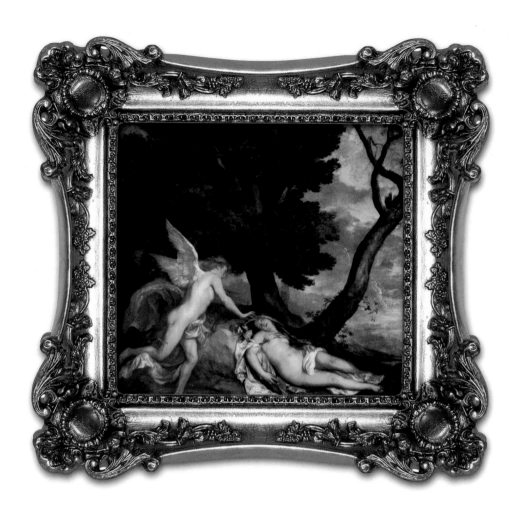

ANTHONY VAN DYCK, FLEMISH
*St. Bernadette Oversleeping for
Her Breakfast Meeting with God*,
1638
Oil on canvas

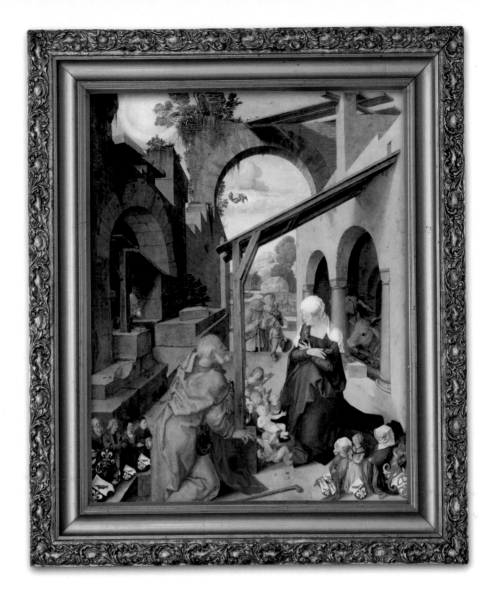

ALBRECHT DÜRER, GERMAN
*Mary Peddling Her
Bobblehead Collection*, 1503
Oil on wood

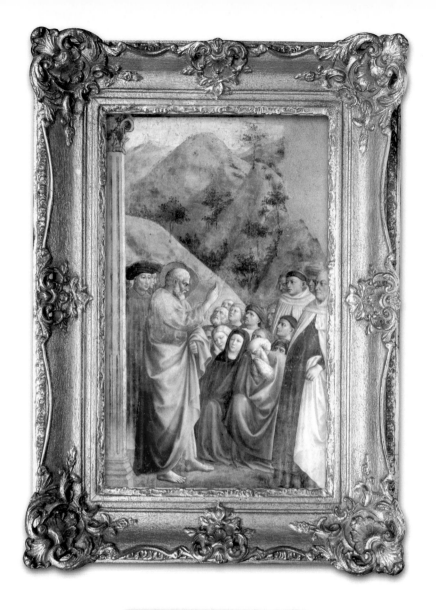

MASACCIO, ITALIAN
*St. Peter Bombing at
Open-Mike Night*, 1424
Oil on canvas

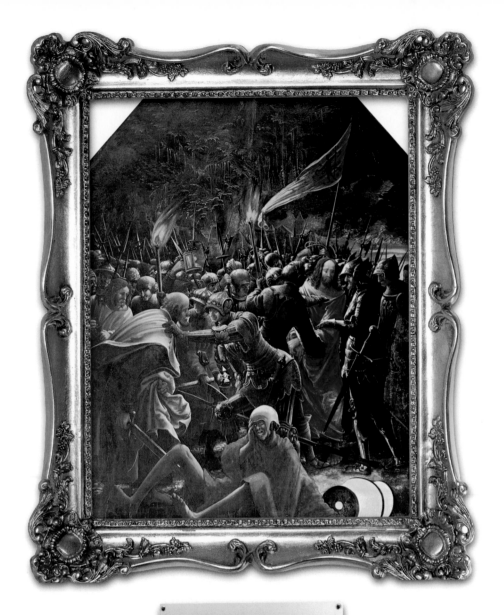

ALBRECHT ALTDORFER, GERMAN
Crowd Control at Jesus's
New Testament Book Signing, 1509
Oil on canvas

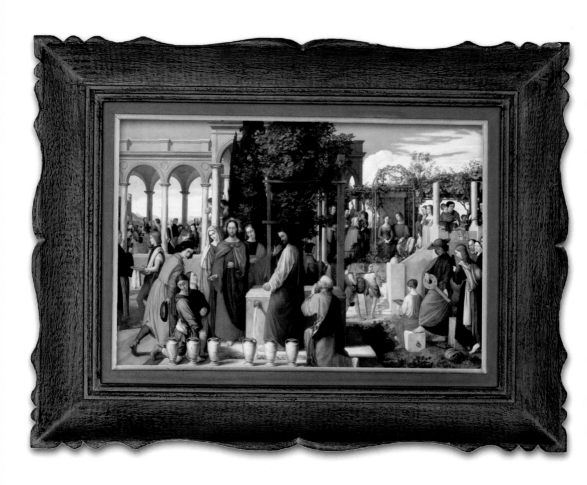

JULIUS SCHNORR VON CAROLSFELD,
GERMAN

*Jesus Turning Water into
Six Pots of Decaf*, 1820

Oil on canvas

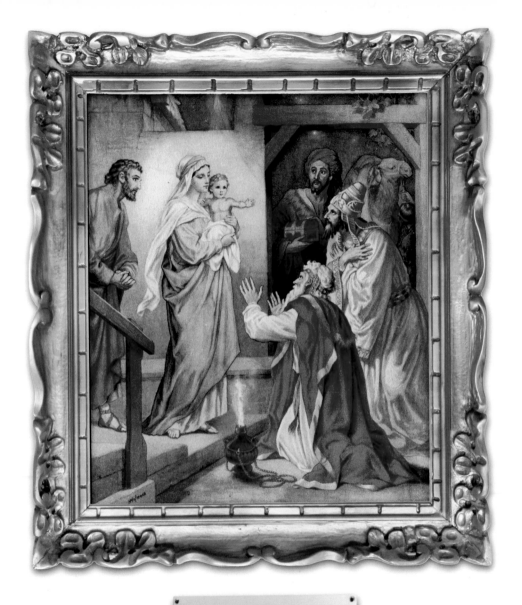

ARTIST UNKNOWN

*Baby Jesus Accusing Wise Men
of Regifting the Frankincense*, 1579

Oil on canvas

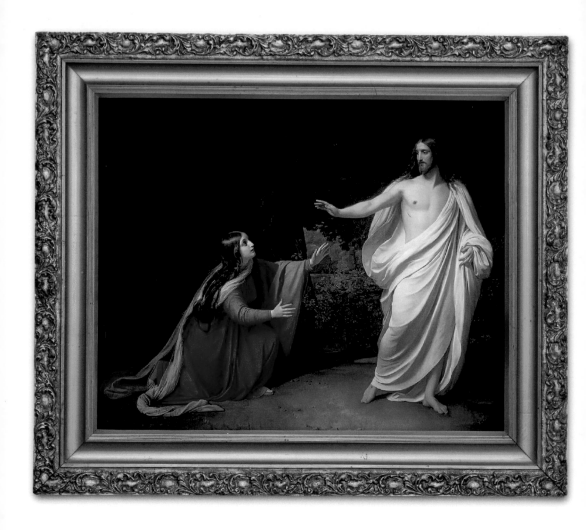

ALEXANDER ANDREYEVICH IVANOV,
RUSSIAN
*Jesus Rejecting Mary Magdalene's
Friend Request,* 1834
Oil on canvas

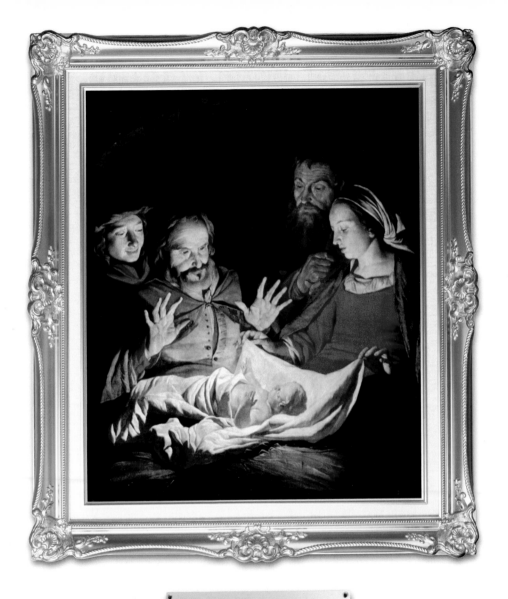

GERARD van HONTHORST, DUTCH

Mary's Parents, Visiting from Florida, 1637

Oil on canvas

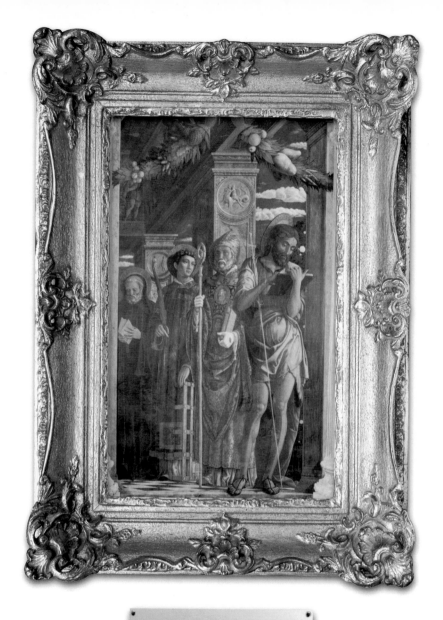

ANDREA MANTEGNA, ITALIAN
Jesus Obsessed with His iPad, 1459
Tempera on canvas

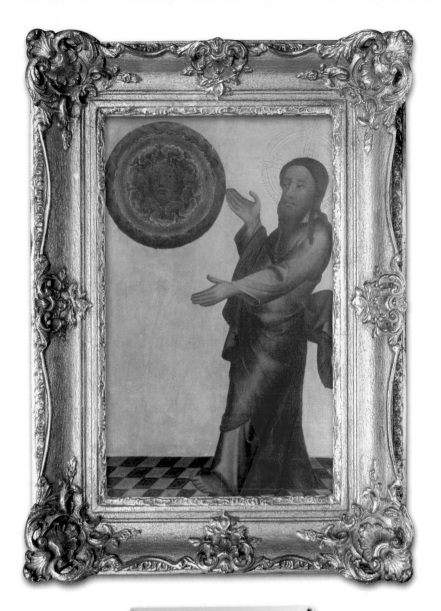

MEISTER BERTRAM VON MINDEN,
GERMAN
*Jesus with Cool Plate He Bought
on His Trip to New Mexico*, 1375
Oil on wood

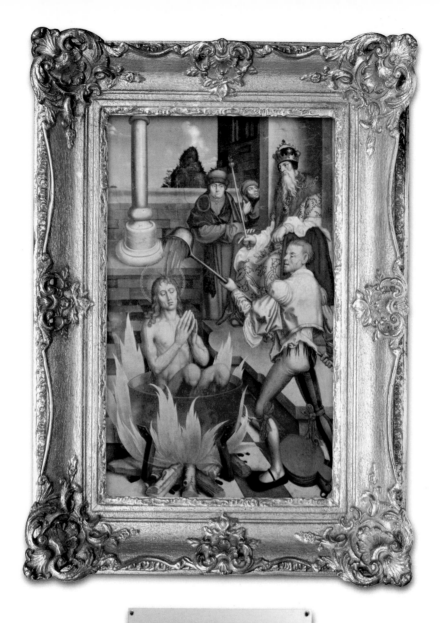

HANS FRIES, SWISS
Making Martyr Noodle Soup, 1514
Oil on canvas

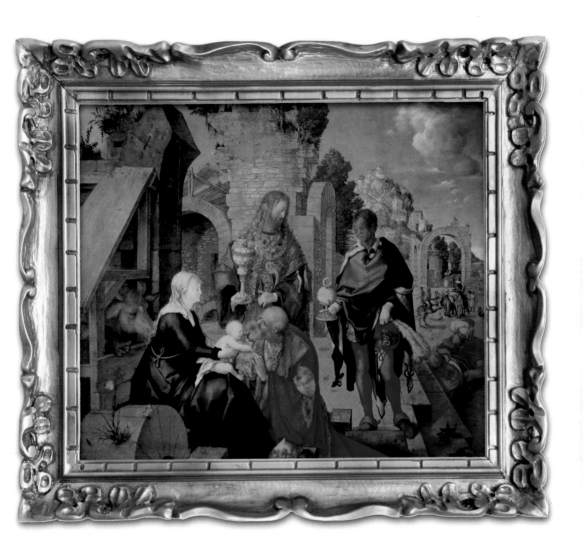

ALBRECHT DÜRER, GERMAN
*Pssst. Nice Globe. But You Left
the Price Tag On*, 1504
Oil on canvas

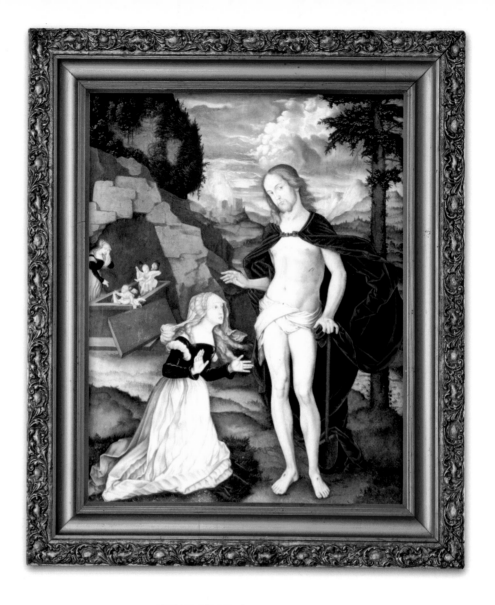

HANS BALDUNG, GERMAN

*Jesus Unveils the
Original Speedo*, 1539

Oil on wood

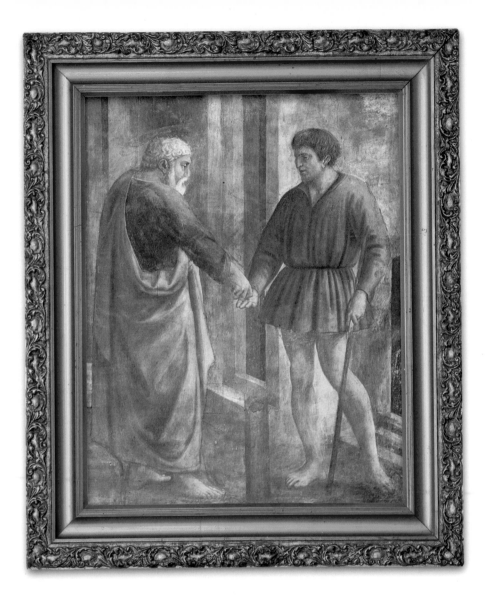

MASACCIO, ITALIAN

*St. Peter Alerting Lunch Companion
That He's Forgotten His Pants*, 1424

Fresco

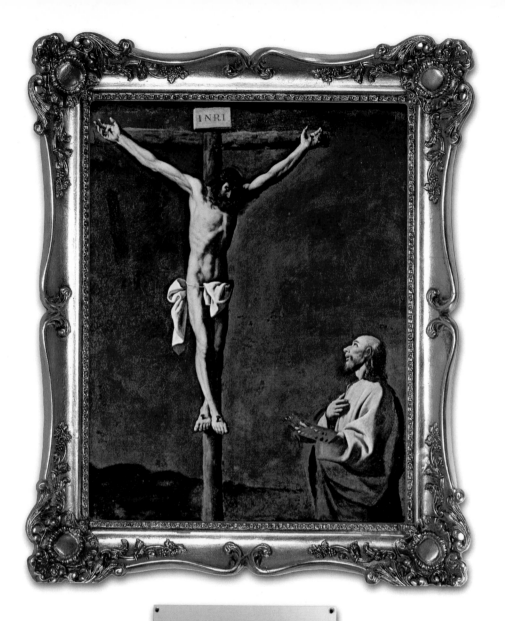

Francisco de Zurbarán, Spanish
*Local News Reporter
Bugging Jesus for a Quote*, 1639
Oil on canvas

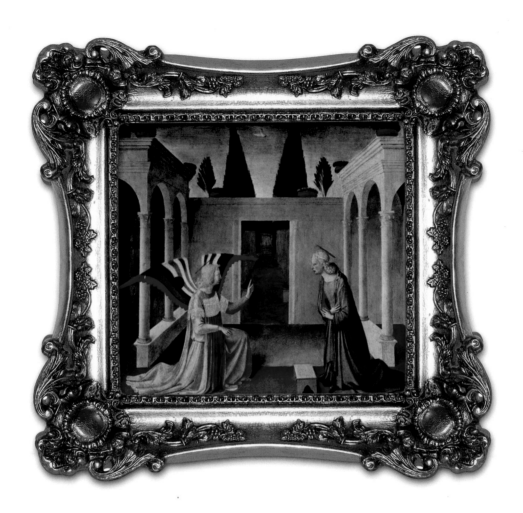

FRA ANGELICO, ITALIAN

*Angel Asking Mary If She Thinks
the New Wings Are Too Much*, 1450

Tempera on wood

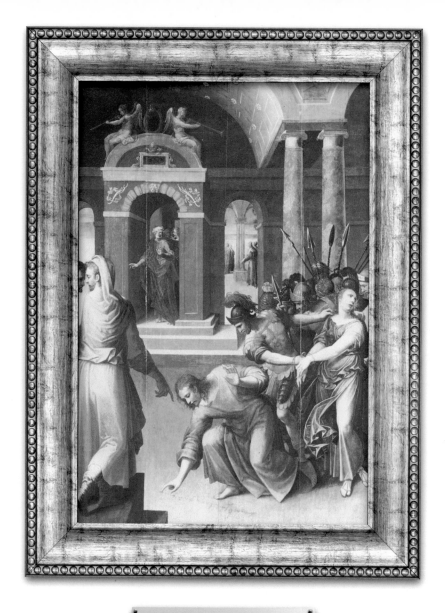

ANTOINE CARON, FRENCH
Hey, Look! A Lucky Penny!
It IS a Good Friday, 1567
Oil on canvas

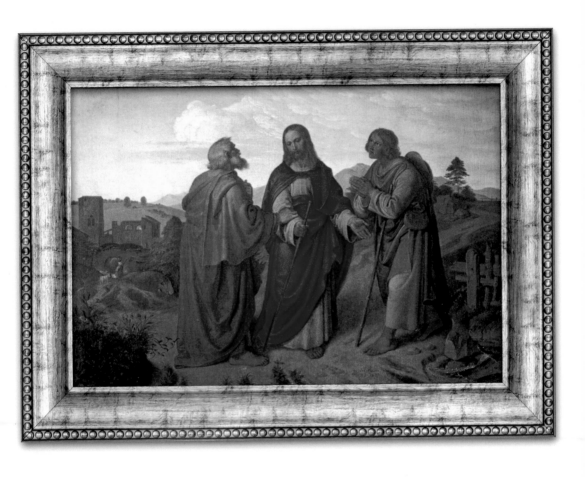

JOSEPH VON FÜHRICH, AUSTRIAN
*Jesus Refusing to
Sign Autographs*, 1837
Oil on canvas

THE BLUE PERIOD

Gratuitous Swearing and Sexual Content

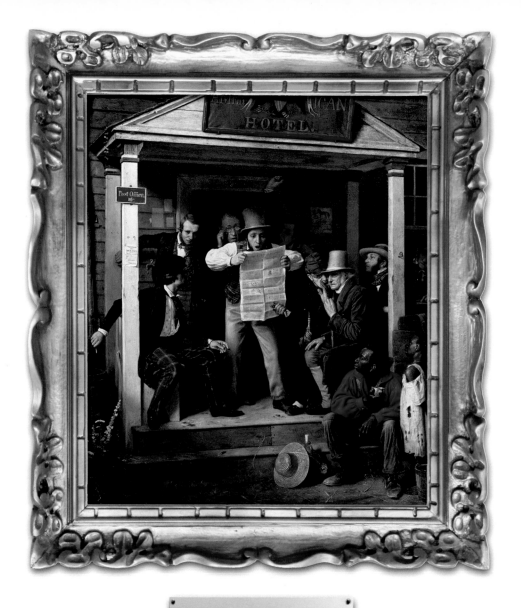

RICHARD CATON WOODVILLE, AMERICAN
*Extra! Extra! Top Hats
Linked to Impotence!*, 1848
Oil on canvas

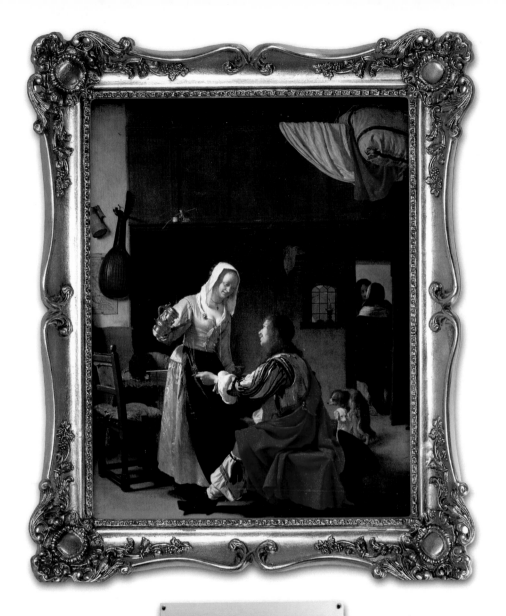

FRANS VAN MIERIS, DUTCH
*Last Call at the
Humping Dog Tavern*, 1658
Oil on panel

EDOUARD MANET, FRENCH
*Trying to Figure Out
Who Shouted, "You Suck!"* 1860
Oil on canvas

WILLIAM-ADOLPHE BOUGUEREAU,
FRENCH

Never You Mind What I'm Wearing.
How Did You Get This Number?, 1885

Oil on canvas

JEAN FOUQUET, FRENCH
Holy Wardrobe Malfunction, 1452
Oil on wood

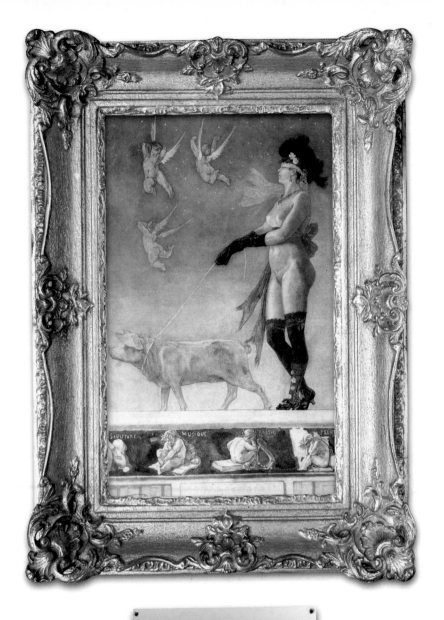

FÉLICIEN ROPS, BELGIAN
*Party Guest Kicking Herself
for Not Picking "Truth,"* 1896
Etching colored with watercolors

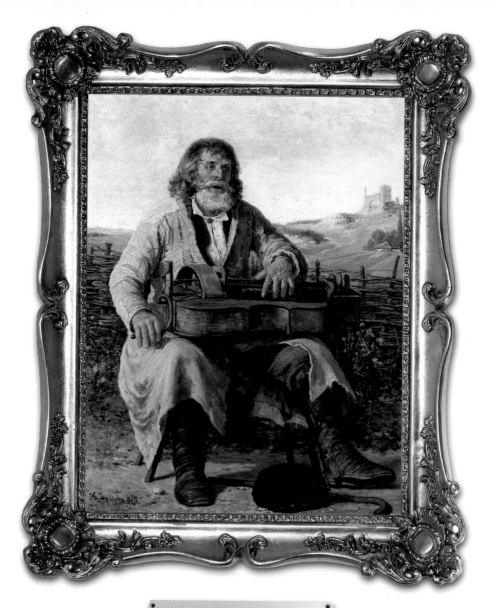

HIPOLIT LIPINSKI, POLISH

Hurdy-Gurdy Player
Catching Testicles in
Crankshaft Mechanism, 1876

Oil on canvas

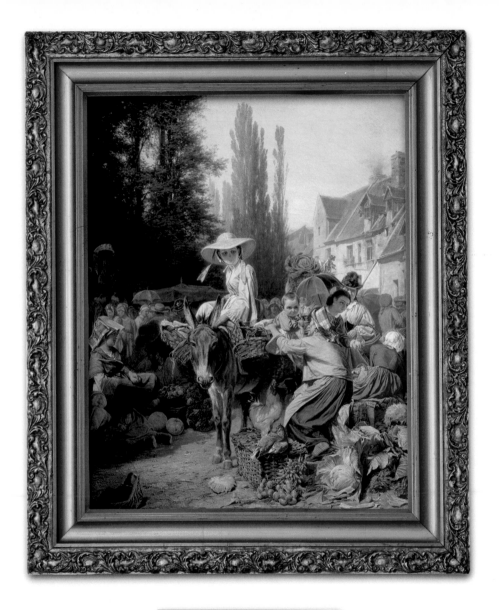

PYOTR NIKOLAYEVICH GRUZINSKY,
RUSSIAN

*Baby Getting Kidnapped While
Mother Sits on Ass*, 1864

Oil on canvas

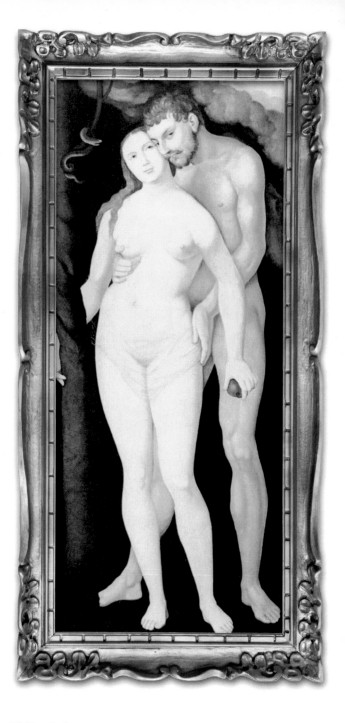

HANS BALDUNG, GERMAN
*Compelling Evidence the Original
Sin Was Sexual Harassment*, 1531
Oil on wood

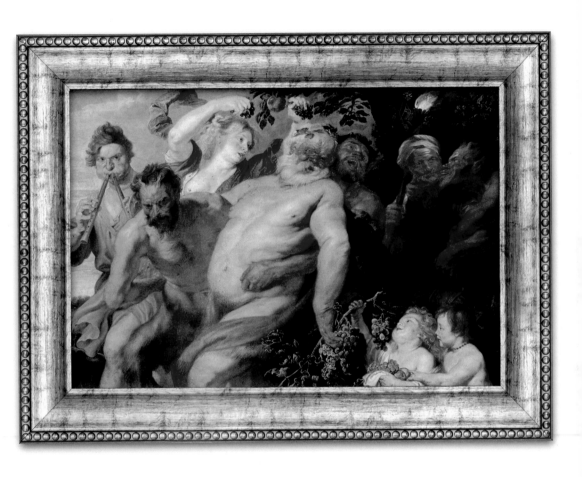

ANTHONY van DYCK, FLEMISH
Santa Claus at Mardi Gras, 1629
Oil on canvas

LUCAS CRANACH THE ELDER, GERMAN

*Thanksgiving at the
Playboy Mansion*, 1546

Oil on wood

AGNOLO BRONZINO, ITALIAN
*Sir Percival, Rethinking the
Nipple Spikes*, 1545
Tempera on canvas

FRANZ KRUGER, GERMAN

*Count Kleinmueller, Not Fooling
Anyone with the Tube Sock*, 1850

Oil on canvas

CARL SPITZWEG, GERMAN
*Jester Making Mental Note Not to
Make Fun of Queen's Fat Ass*, 1855
Oil on canvas

SALOMON KONINCK, DUTCH
*"Hustler" Magazine before
Photography*, 1643
Oil on canvas

JOACHIM LUHN, GERMAN
*Group Reacting to Total Stranger
Shouting, "Hey, Assholes!,"* 1700
Oil on canvas

JAN STEEN, DUTCH

*Smart-ass Pouring Chamber Pot
into Water Pitcher*, 1661

Oil on canvas

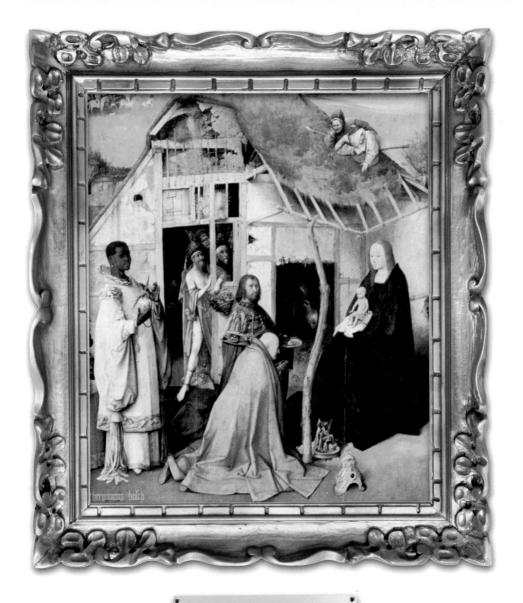

HIERONYMUS BOSCH, DUTCH
The Three Wise Men, Plus a Fourth Who Showed Up Naked, 1510
Oil on panel

JOHN WILLIAM WATERHOUSE, ENGLISH

*The Nurses of Athens General
on Bedpan Duty*, 1903

Oil on canvas

JAN STEEN, DUTCH
*Amish Stripper
Dressing for Work*, 1685
Oil on wood

JEAN-AUGUSTE-DOMINIQUE INGRES,
FRENCH

*Bondage Freak Trying to Remember
Her Safe Word*, 1819

Oil on canvas

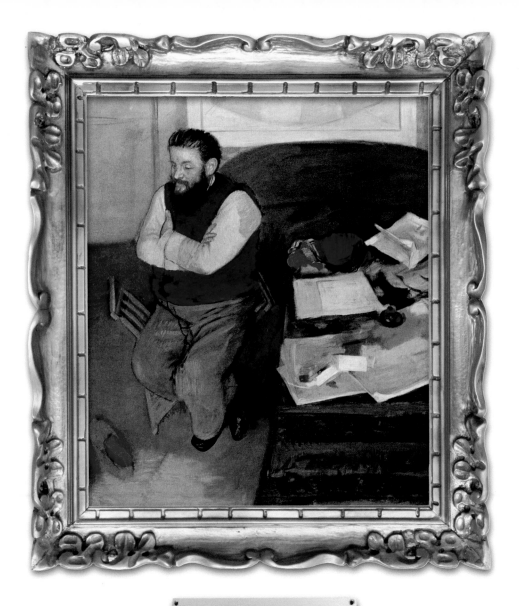

EDGAR DEGAS, FRENCH
My A-hole Roommate, Refusing to Clean Up His Crap, 1879
Oil on canvas

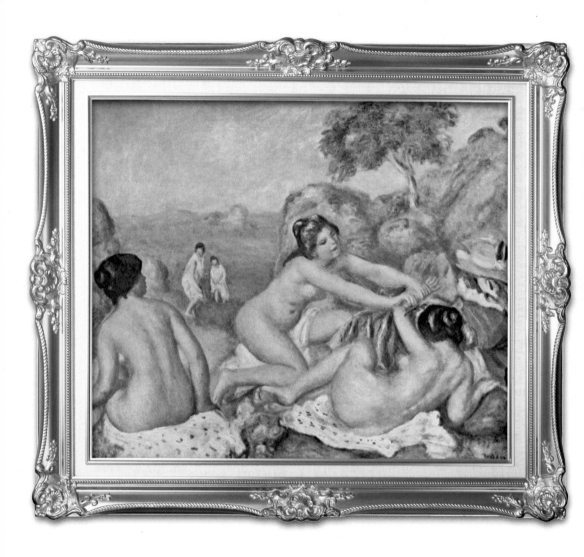

PIERRE-AUGUSTE RENOIR, FRENCH

*Collette Learns to Ask before
Borrowing Sunblock*, 1897

Oil on canvas

MASTERWORKS REWORKED

Artwork That's Been Tweaked by the Author

ONE DRINK TWO DRINKS THREE DRINKS

JOHN WILLIAM GODWARD, ENGLISH
*Effect of Alcohol on Model's
Willingness to Pose Nude*, 1913
Oil on canvas

VINCENT VAN GOGH, DUTCH
*Me Goofing Around in
Mall Photo Booth*, 1887
Oil on canvas

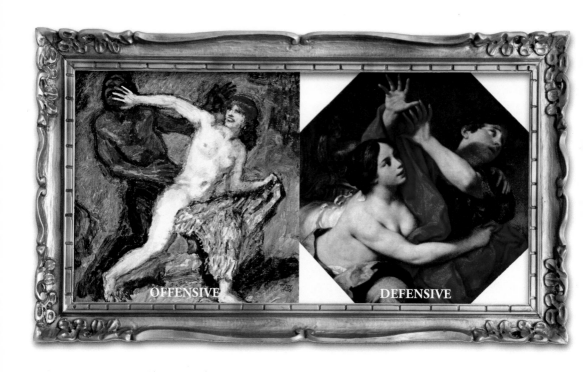

OFFENSIVE

DEFENSIVE

CARLO CIGNANI, ITALIAN

*Nymphs Committing Blatant
Pass Interference*, 1680

Oil on canvas

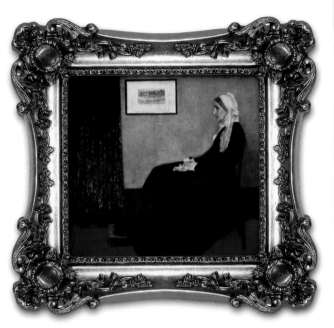

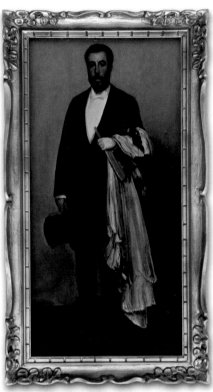

JAMES MCNEILL WHISTLER, AMERICAN
Portrait of the Artist's Mother, 1871
Oil on canvas

JAMES MCNEILL WHISTLER, AMERICAN
*Portrait of the Artist's
Mother's Dry Cleaning*, 1883
Oil on canvas

DOUBLE FEATURE

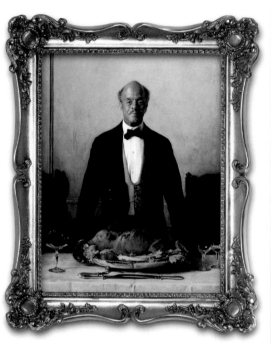

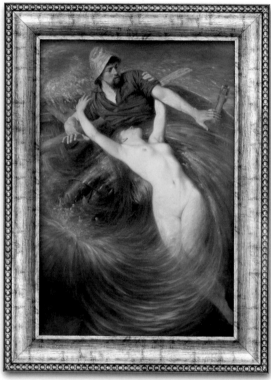

JOSEPH DeCAMP, AMERICAN
"Charlotte's Web: The Lost Ending,"
1919
Oil on canvas

KNUT EKVALL, SWEDISH
"The Little Mermaid 4: Boy Crazy,"
1904
Oil on canvas

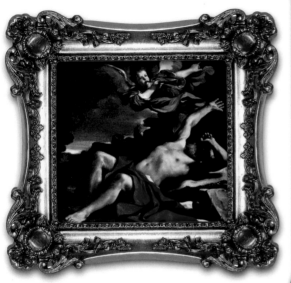

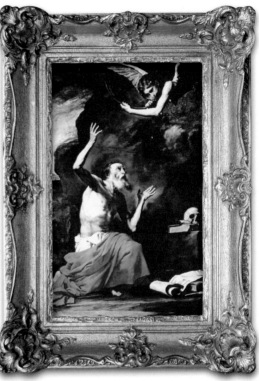

GUERCINO VISIONE, ITALIAN
*Douchebag Blowing Trumpet at
Four in the Morning*, 1629
Oil on canvas

JOSE DE RIBERA, SPANISH
*Same Douchebag Blowing Trumpet
While Old Guy's Trying to Work*, 1626
Oil on canvas

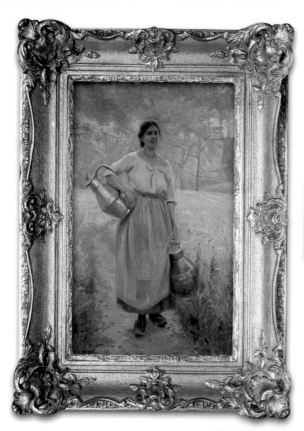

ELISABETH KEYSER, SWEDISH
*Woman with Nice Jugs
(No Pun Intended)*, 1881
Oil on canvas

ANTONIO PARREIRAS, PORTUGUESE
*Woman with Nice Jugs
(Pun Intended)*, 1909
Oil on canvas

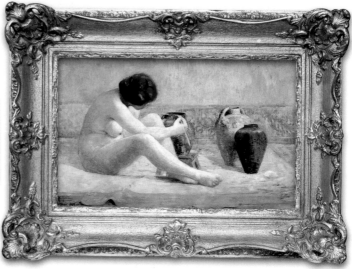

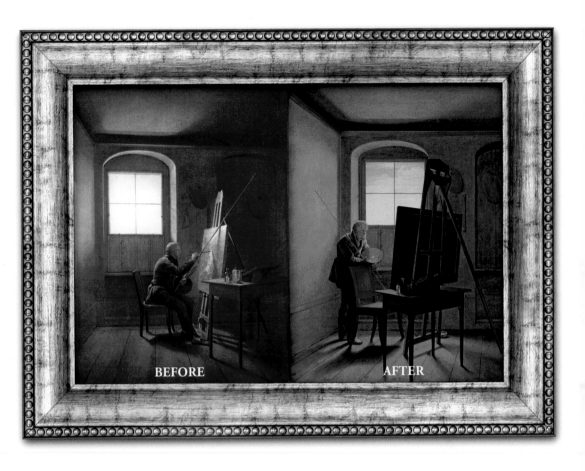

BEFORE

AFTER

GEORG FRIEDRICH KERSTING, GERMAN

*Dramatic Evidence of Loss of
Productivity Since Artist Got
New Wide-Screen TV*, 1811

Oil on canvas

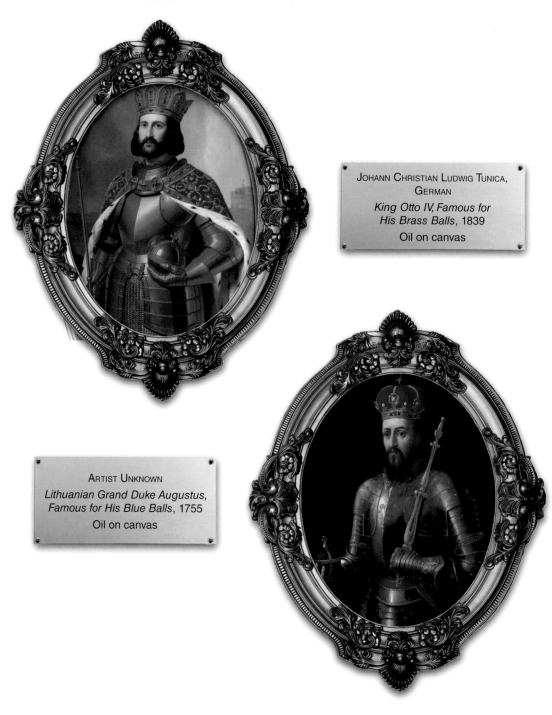

JOHANN CHRISTIAN LUDWIG TUNICA,
GERMAN
*King Otto IV, Famous for
His Brass Balls*, 1839
Oil on canvas

ARTIST UNKNOWN
*Lithuanian Grand Duke Augustus,
Famous for His Blue Balls*, 1755
Oil on canvas

HAPPY HOLIDAYS

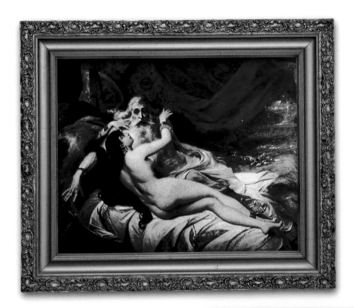

PEDRO AMÉRICO, BRAZILIAN
*Happy Valentine's Day, from
Michael Douglas and
Catherine Zeta-Jones*, 1879
Oil on canvas

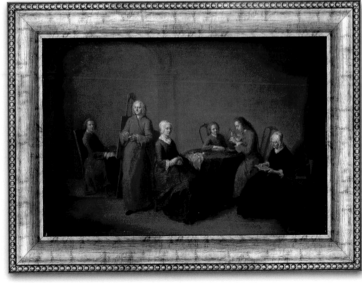

BERNARD RODE, GERMAN
*The Abstinence Society's
Christmas Party*, 1745
Oil on canvas

STUDY IN LIGHT AND DARK

Darker Jokes for Those
Who Take Their Humor Black

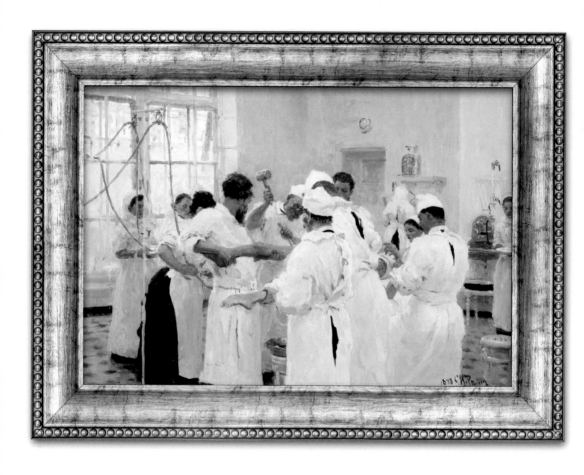

ILYA YEFIMOVICH REPIN, RUSSIAN

*Sign You May Need a
New HMO*, 1888

Oil on canvas

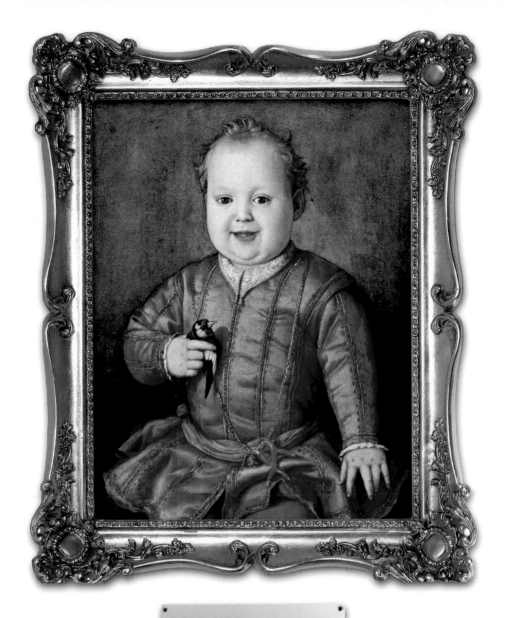

AGNOLO BRONZINO, ITALIAN
This Can't End Well, 1545
Tempera on canvas

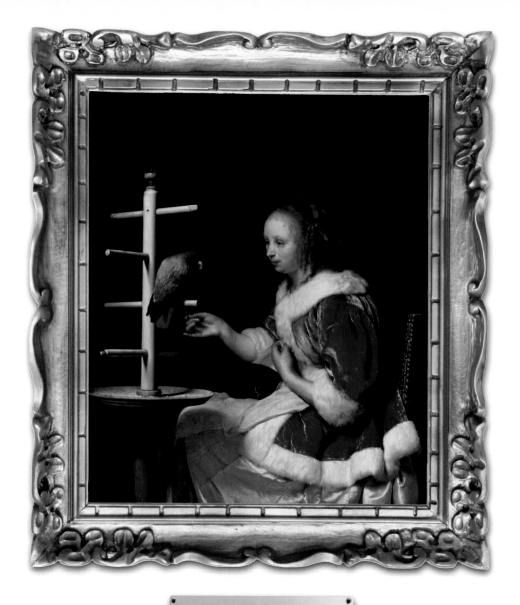

FRANS VAN MIERIS THE ELDER, DUTCH
*How Catherine the Four-fingered
Got Her Nickname*, 1663
Oil on panel

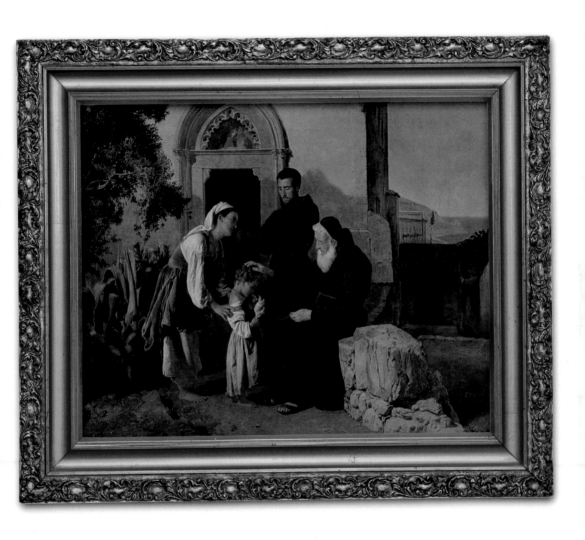

FERDINAND GEORG WALDMÜLLER,
AUSTRIAN

*Woman Trading Daughter for a
Case of Benedictine Wine*, 1846

Oil on wood

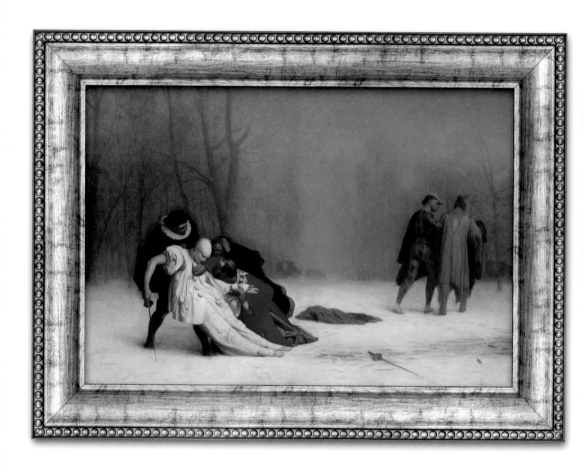

JEAN-LÉON GÉRÔME, FRENCH
Murder at Cirque du Soleil, 1854
Oil on canvas

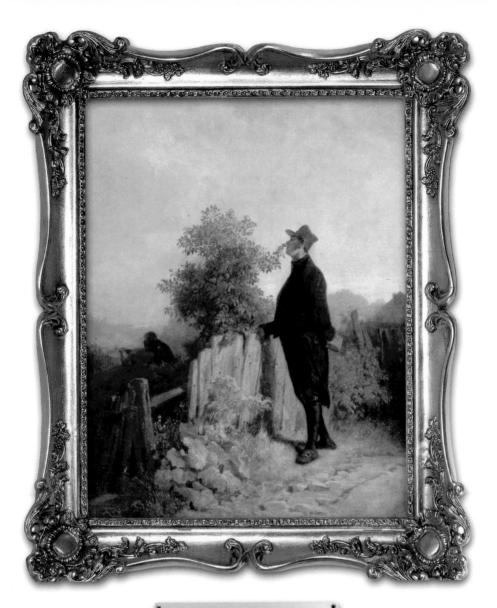

CARL SPITZWEG, GERMAN

Creep Maintaining Court-ordered
One-hundred-yard Distance
from Playground, 1840

Oil on canvas

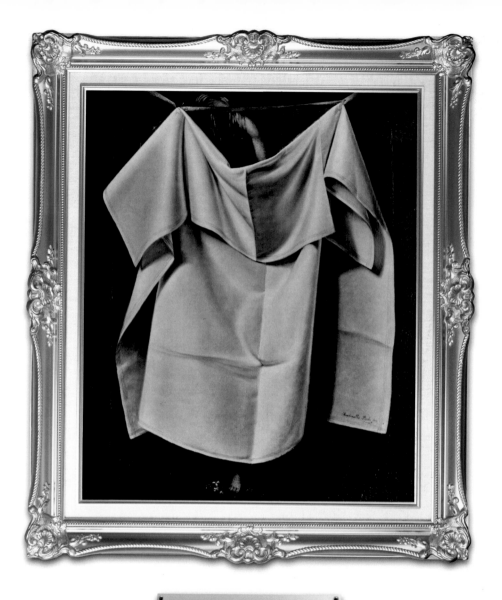

RAPHAELLE PEALE, AMERICAN

*Laundry Day at the
Grand Wizard's House*, 1823

Oil on canvas

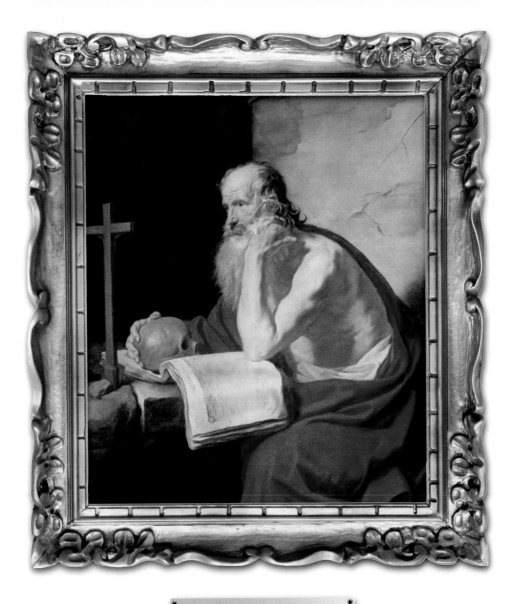

JACQUES BLANCHARD, FRENCH
*Serial Killer Bummed the Paper
Spelled His Name Wrong*, 1632
Oil on canvas

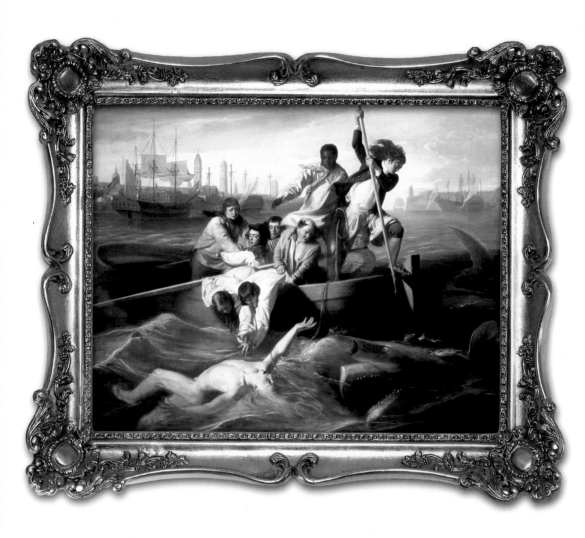

JOHN SINGLETON COPLEY, AMERICAN
In Retrospect, Probably Not the Best Place to Snorkel, 1778
Oil on canvas

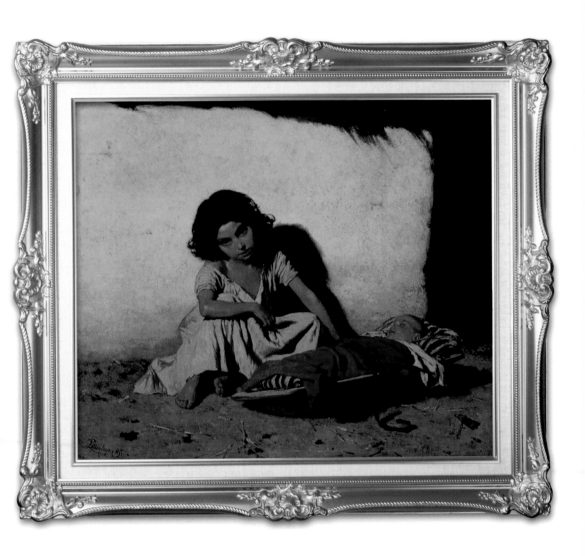

AUGUST XAVER KARL
VON PETTENKOFEN, AUSTRIAN

*Walmart Sweatshop Worker Enjoying
Monthly Five-minute Break*, 1855

Oil on canvas

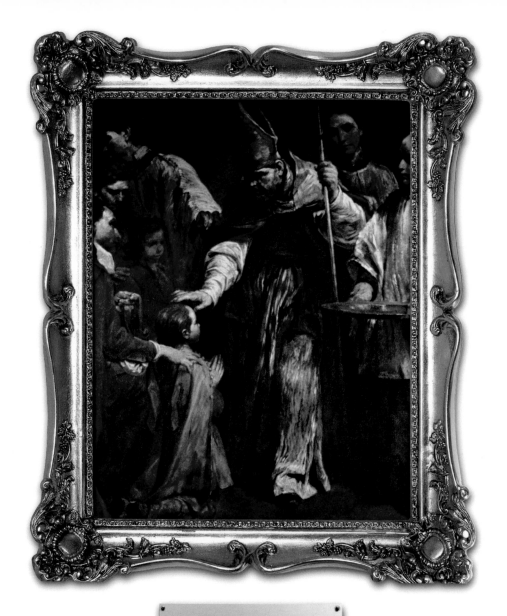

GIUSEPPE MARIA CRESPI, ITALIAN
*Bishop Giordano, Violating
the Terms of His Probation*, 1712
Oil on canvas

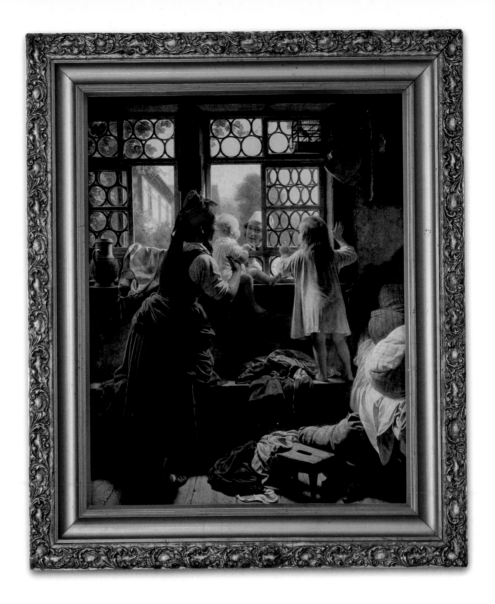

FRIEDRICH EDUARD MEYERHEIM, GERMAN

*World's First Drive-thru
Adoption Agency*, 1858

Oil on canvas

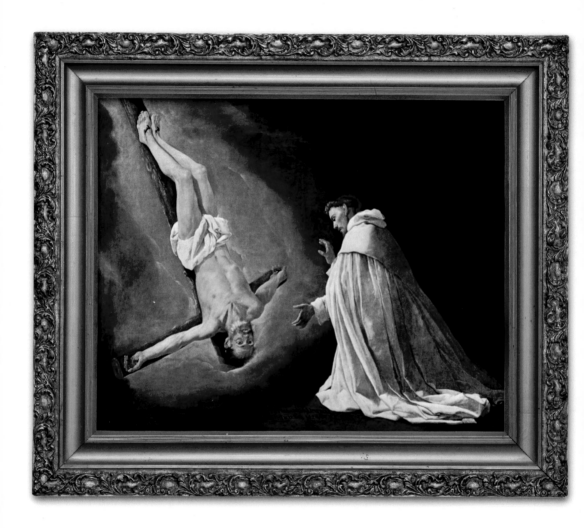

FRANCISCO DE ZURBARAN, SPANISH

*St. Peter's Lawyer Assuring Him
He'll Have Him Out by Morning,*
1629

Oil on canvas

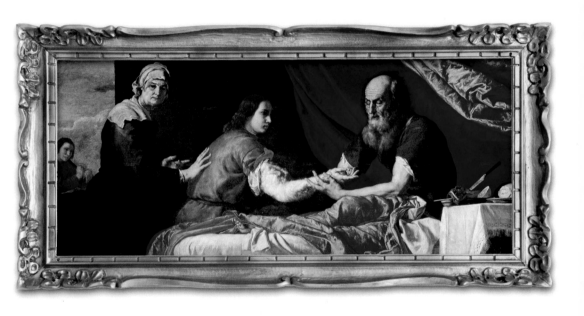

JOSÉ DE RIBERA, SPANISH

Elderly Couple Working at Massage Parlor to Make Ends Meet, 1637

Oil on canvas

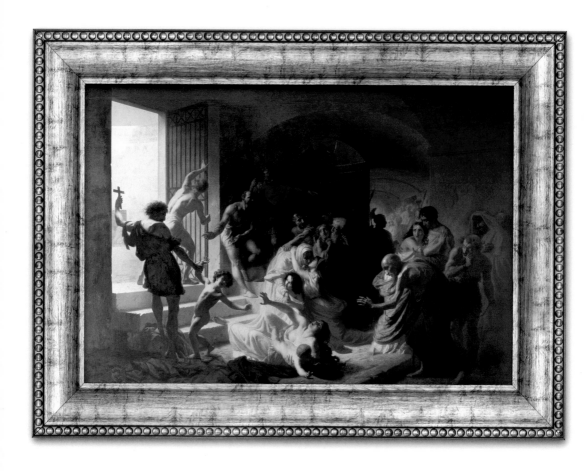

KONSTANTIN FLAVITSKY, RUSSIAN
*Scene at Drop-off on First Day
of Catholic School*, 1862
Oil on canvas

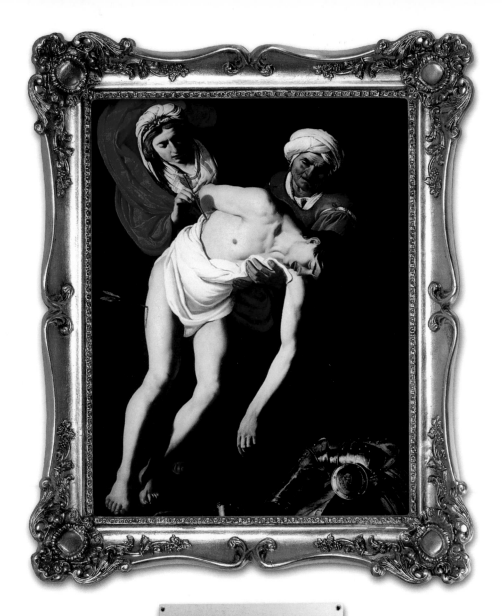

DIRCK VAN BABUREN, DUTCH
*St. Sebastian Insisting
He's Okay to Drive*, 1615
Oil on canvas

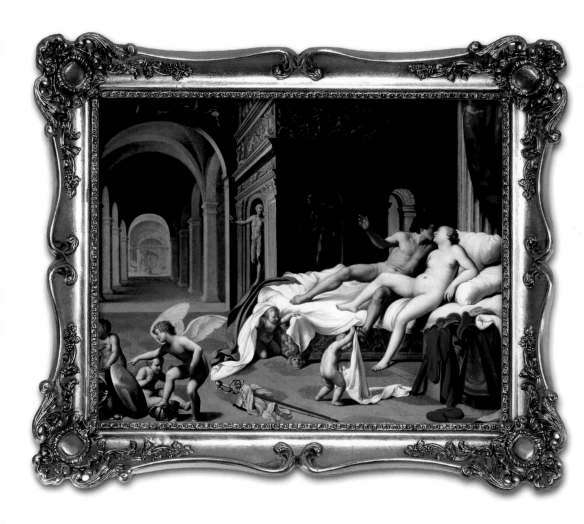

CARLO SARACENI, ITALIAN
World's Worst Day Care Center,
1600
Oil on copper

THE ROMANTIC MOVEMENT

Paintings of Love

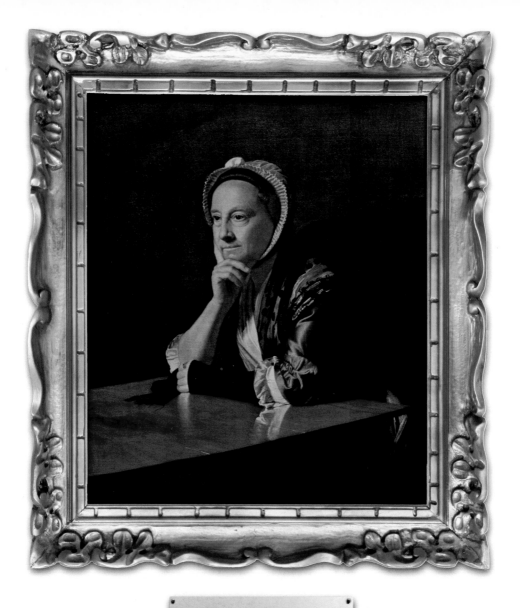

JOHN SINGLETON COPLEY, AMERICAN
The Artist's Mother, Reminiscing about Banging Ben Franklin, 1771
Oil on canvas

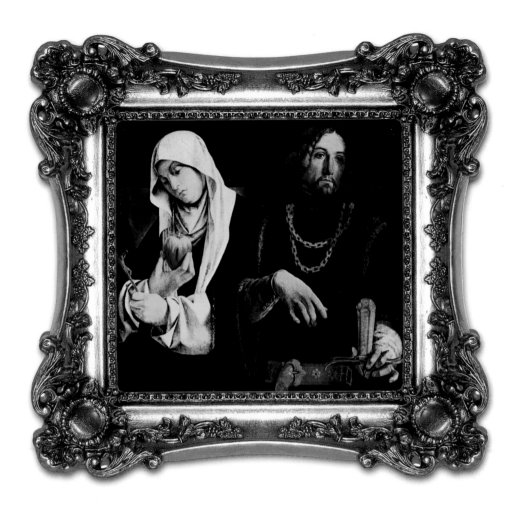

LORENZO LOTTO, ITALIAN
*Mary and Joseph in
Couples Counseling*, 1508
Oil on wood

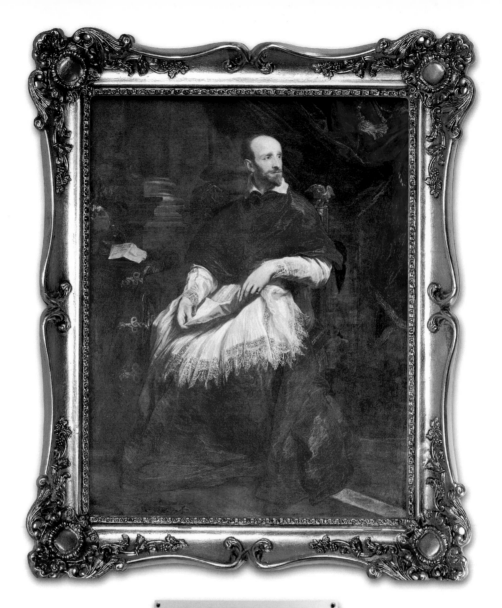

ANTHONY VAN DYCK, FLEMISH

*Cardinal Guido Bentivoglio,
Wondering Who This "Secret Admirer"
Might Be*, 1633

Oil on canvas

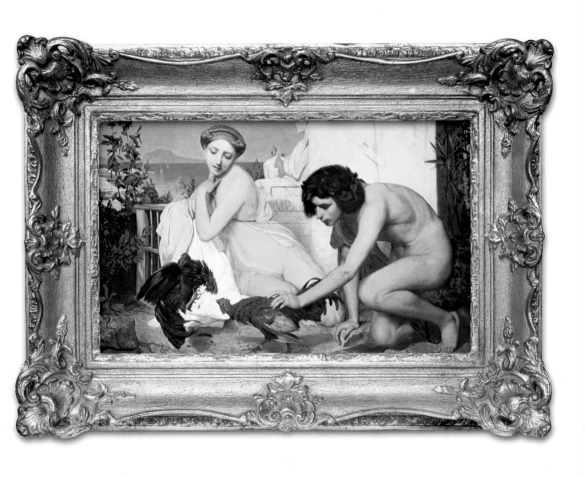

JEAN-LÉON GÉRÔME, FRENCH

*Setting the Mood with
a Romantic Cockfight*, 1846

Oil on canvas

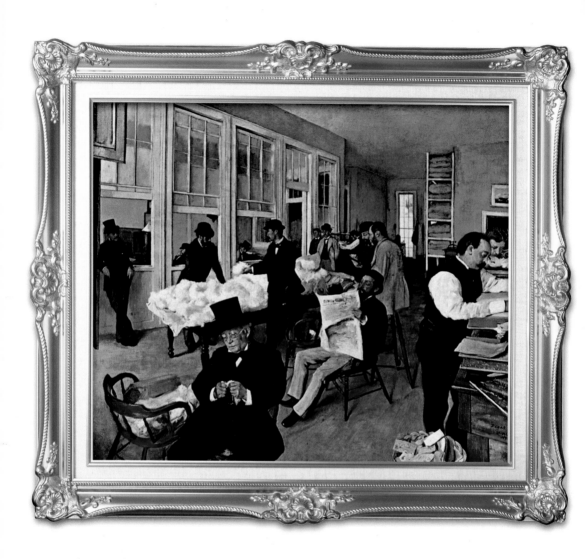

EDGAR DEGAS, FRENCH
*Buying Wives Malteses for
Mother's Day*, 1873
Oil on canvas

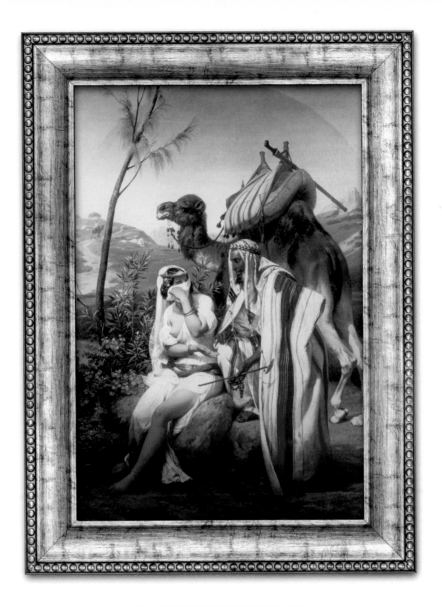

ÉMILE JEAN-HORACE VERNET, FRENCH
P.U. Was That You or the Camel?,
1840
Oil on canvas

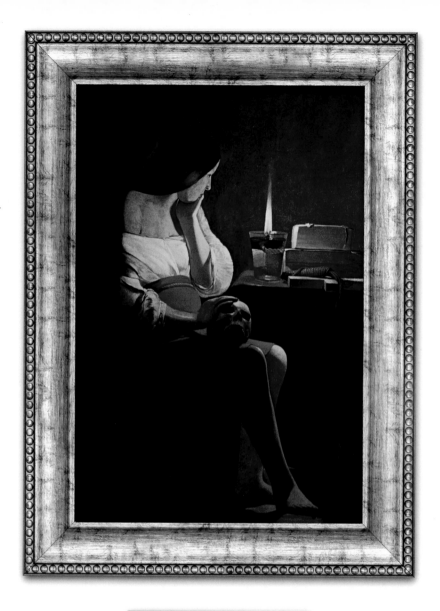

GEORGES DE LA TOUR, FRENCH

*Woman and Her Ex, Observing
Anniversary of His Affair*, 1626

Oil on canvas

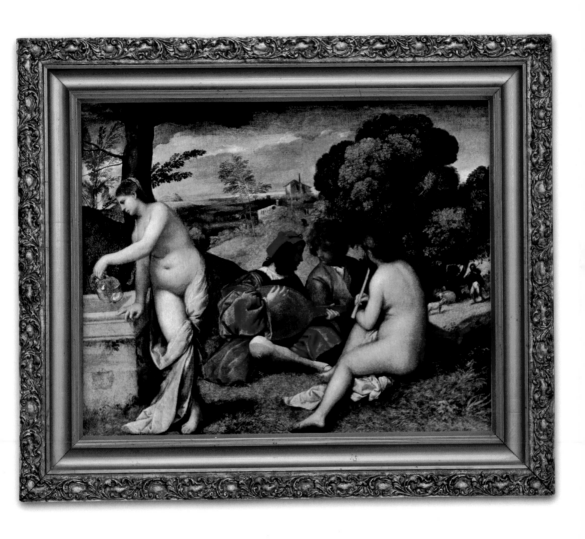

TITIAN, ITALIAN
*I've Got Flute Girl. You Take
the Weird Friend*, 1505
Oil on canvas

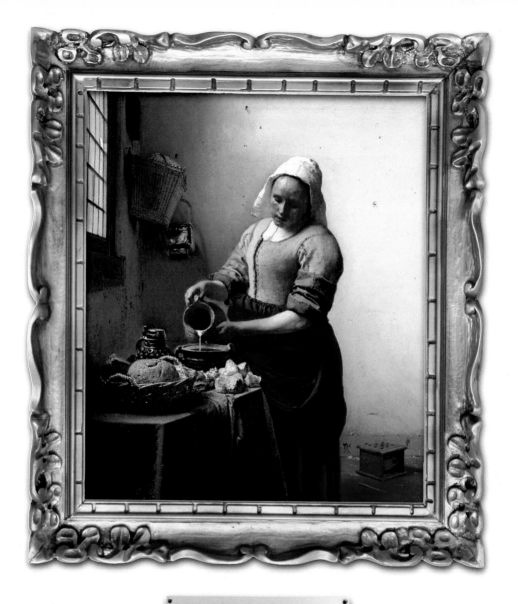

JAN VERMEER, DUTCH

Woman Pouring Ex-Lax into Cheating Husband's Soup, 1660

Oil on canvas

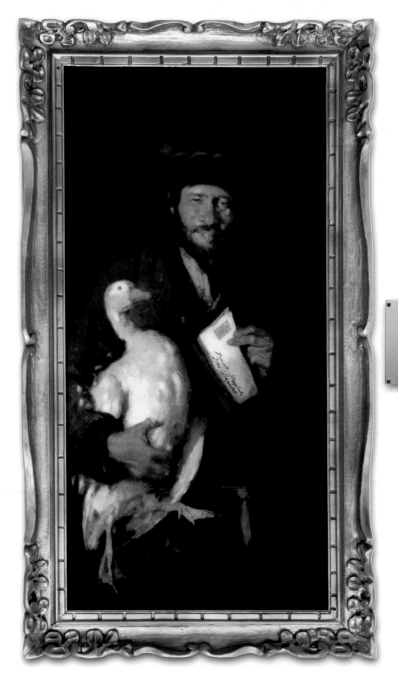

NICOLAE GRIGORESCU,
ROMANIAN
*Vlad and Lucky Mailing Their
Wedding Announcement*, 1850
Oil on canvas

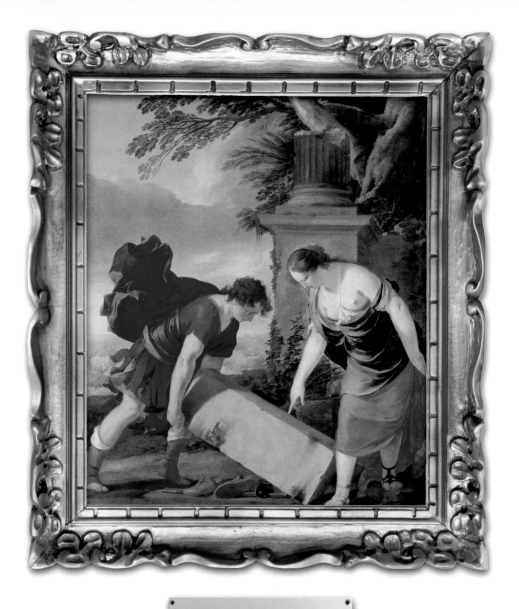

LAURENT DE LA HYRE, FRENCH
*Putting a Woman on a Pedestal:
Step 1 of 4*, 1635
Oil on canvas

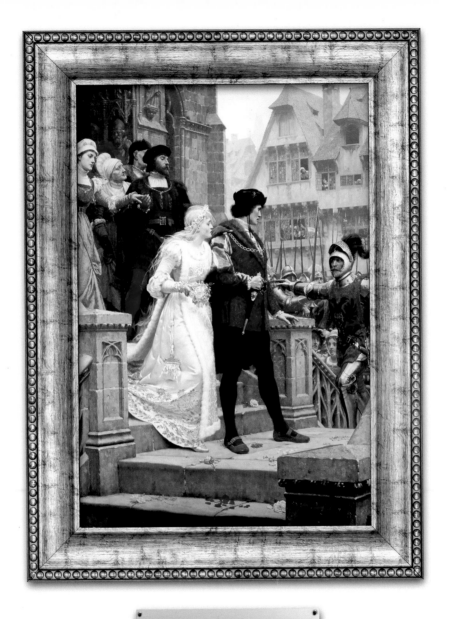

EDMUND BLAIR LEIGHTON, ENGLISH
Newlyweds Being Informed That Their Limo Just Got Towed, 1888
Oil on canvas

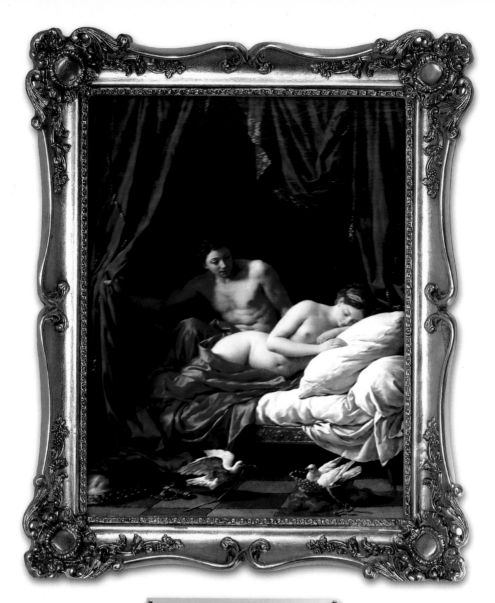

LOUIS JEAN FRANCOIS LAGRENEE,
FRENCH

*Morning after the New Year's Eve Party
(Trying to Remember Her Name)*, 1770

Oil on canvas

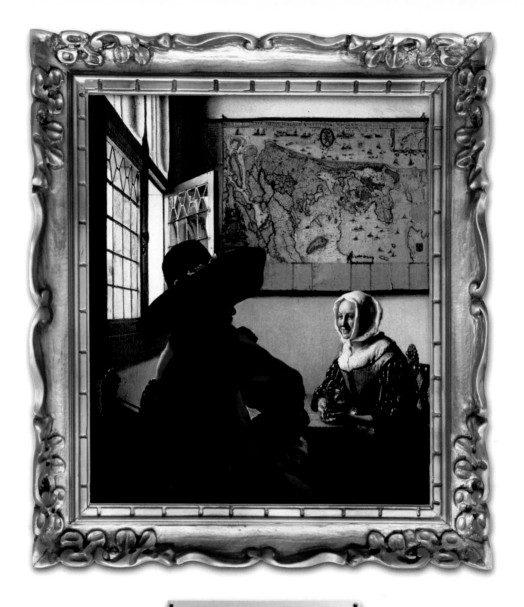

JAN VERMEER, DUTCH
Elsa Tries Speed Dating, 1657
Oil on canvas

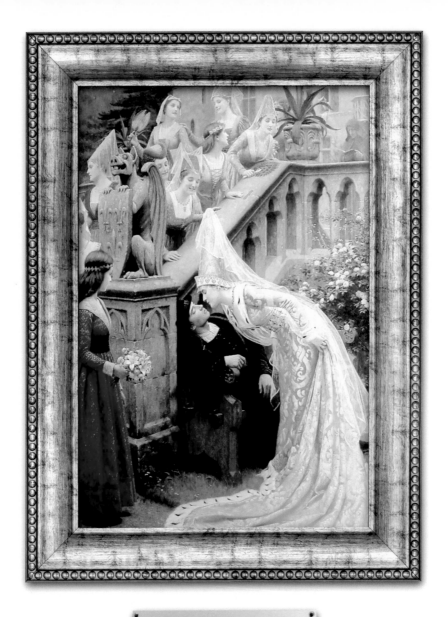

EDMUND BLAIR LEIGHTON, ENGLISH
Scientology Wedding, 1903
Oil on canvas

MASTERS OF
THEIR DOMAIN

Home Life

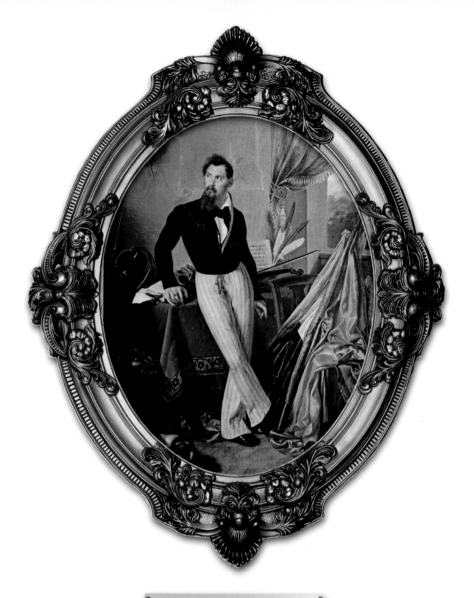

FRANCESCO HAYEZ, ITALIAN

Italian Count in Pajama Bottoms,
Waiting for Pants to Come Out
of the Dryer, 1860

Oil on canvas

GEORGE MORLAND, ENGLISH
*Showdown over a
Root Beer Float*, 1792
Oil on canvas

ALBERT LYNCH, PERUVIAN
*boredgrl35, Wishing They'd
Hurry Up and Invent the
Internet Already*, 1881
Oil on canvas

JAN VERMEER, DUTCH

*Man Trying to Decide If His
Shrimp Lo Mein Has Turned*, 1669

Oil on canvas

JOHANN HEINRICH WILHELM TISCHBEIN,
GERMAN

*Portrait of the Artist in
His Snuggie*, 1787

Oil on canvas

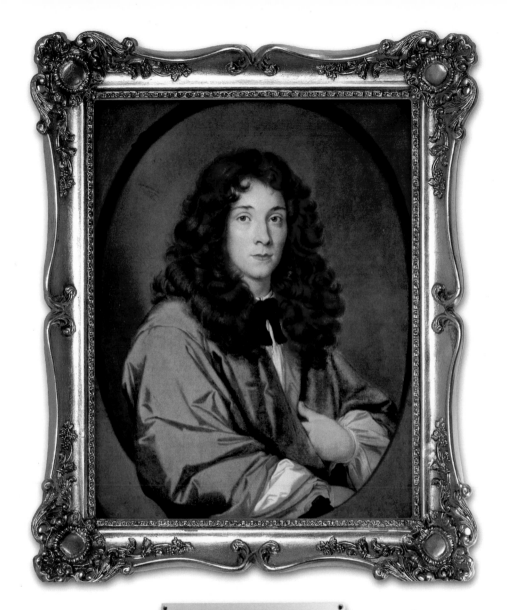

FRANZOSISCHER MEISTER, DUTCH

*Guess Who Found His
Mom's Curling Iron*, 1650

Oil on canvas

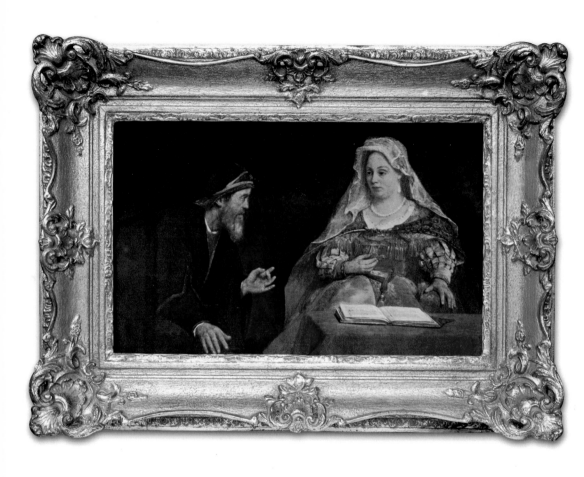

AERT DE GELDER, DUTCH
*Lady Anne of Cornwall, First Recorded
Victim of "The Booger Flick,"* 1685
Oil on canvas

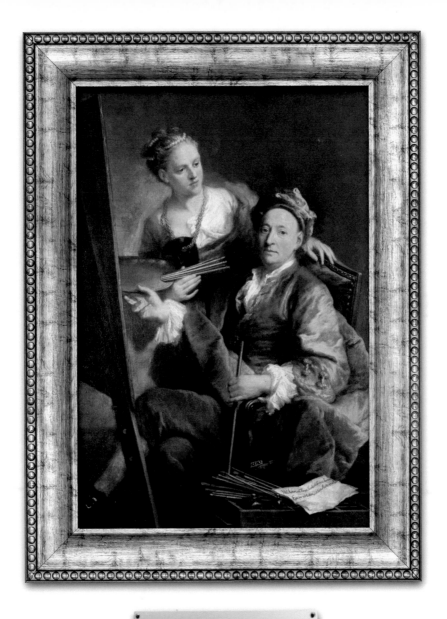

GEORGE DESMAREES, FRENCH

The Artist, Suddenly Regretting His Decision to Work from Home, 1750

Oil on canvas

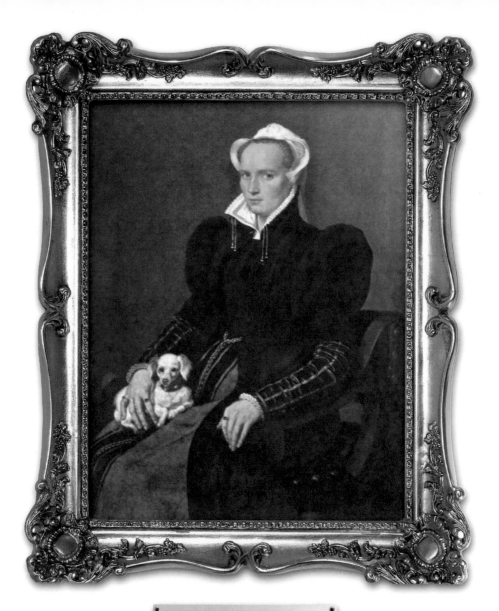

ANTONIS MOR, DUTCH
Portrait of Duchess von Manhanz,
1554
Oil on canvas

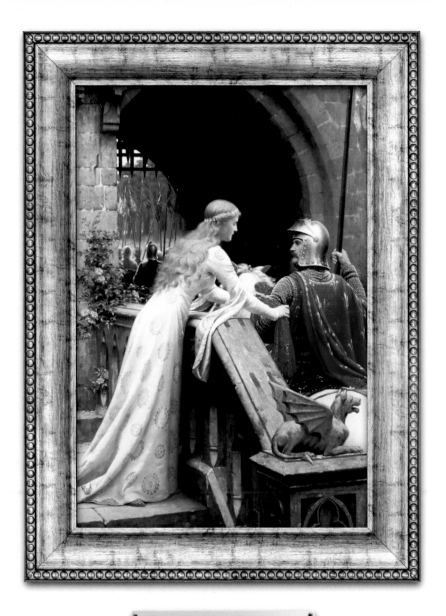

EDMUND BLAIR LEIGHTON, ENGLISH

Sir Galahad Being Reminded to Pick Up Some 2% While He's Out,
1900

Oil on canvas

HENRI FANTIN-LATOUR, FRENCH

Party of Seven Realizing They're Way Overdressed for the Olive Garden, 1872

Oil on canvas

FRANCISZEK SMUGLEWICZ, POLISH

*King Darius Accepting Delivery
of an Extra-large Pepperoni
and Mushroom*, 1785

Oil on canvas

ERNEST LAURENT, FRENCH

Witness Protection Program's
Family of the Year (the Doe's), 1921

Oil on canvas

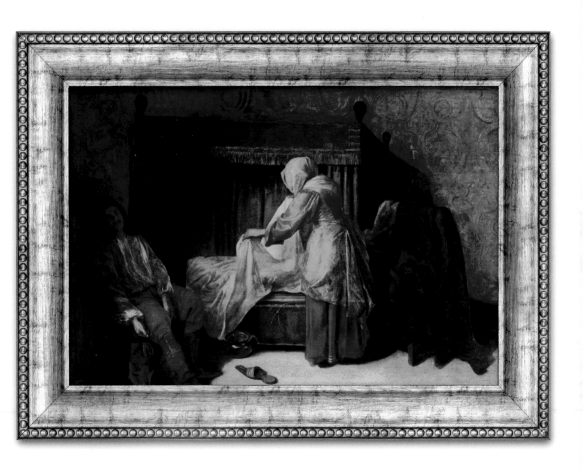

PIETER DE HOOCH, DUTCH
The Bed Wetter's Shame, 1655
Oil on canvas

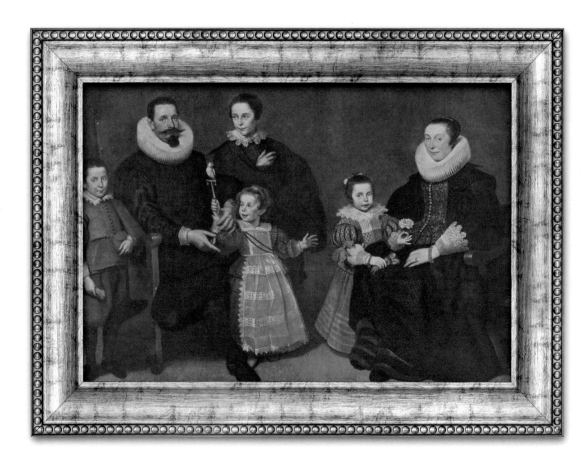

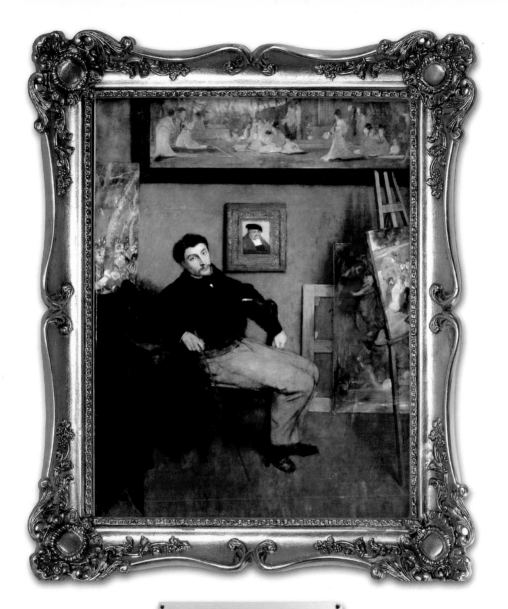

EDGAR DEGAS, FRENCH
Portrait of the Artist in Mom Jeans,
1867
Oil on canvas

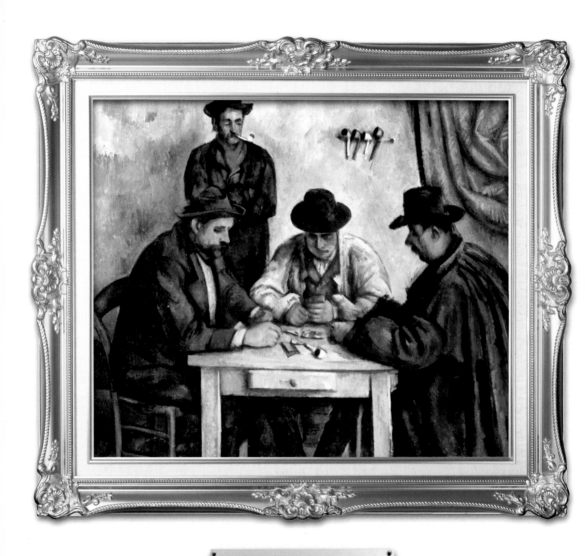

PAUL CÉZANNE, FRENCH

*Three Guys Checking
Their BlackBerrys*, 1890

Oil on canvas

CHARLES COURTNEY CURRAN, AMERICAN

*Another Satisfied Jenny Craig
Customer (with "Before" Painting),*
1887

Oil on canvas

MEISTER DES URSULAZYKLUS, GERMAN

*The Tooth Fairy, Running Down
List of Legal Disclaimers*, 1498

Oil on canvas

SOPHIE GENGEMBRE ANDERSON,
ENGLISH

*Little Lord Fauntleroy
Under House Arrest*, 1856

Oil on canvas

ARTISTS AT WORK

Taking Care of Business

JOSÉ DE RIBERA, SPANISH
*The Artist, Realizing He
Forgot to Bring His Lunch*, 1651
Oil on canvas

GEERTGEN TOT SINT JANS, DUTCH
*Shepherd Reconsidering Whether
Grad School Was Worth It*, 1490
Oil on oak

GERARD TER BORCH, DUTCH
*Take Our Daughters to
Indentured Servitude Day*, 1649
Oil on canvas

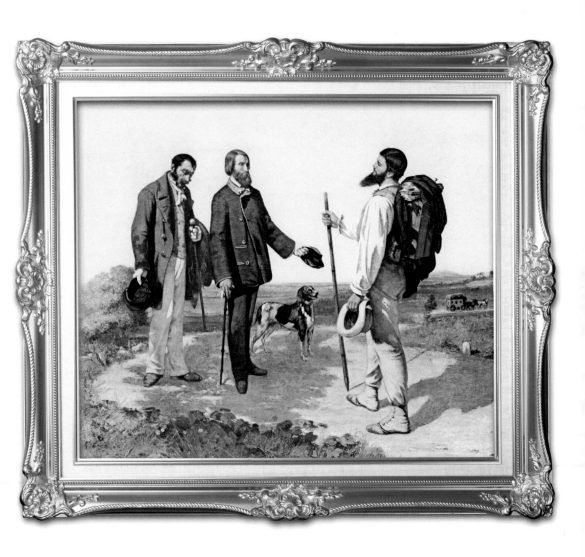

GUSTAVE COURBET, FRENCH
*Travelers Stopping to Insult Each
Other's Beards*, 1854
Oil on canvas

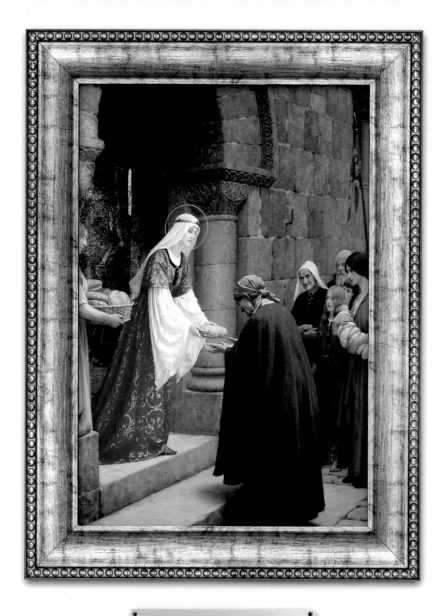

EDMUND BLAIR LEIGHTON, ENGLISH

*Calzone Friday at Our
Lady of Mercy*, 1895

Oil on canvas

BARTHOLOMEUS VAN DER HELST,
DUTCH
*Wait. You Painted ME? I Thought
I Was Painting YOU*, 1654
Oil on canvas

JUAN PANTOJA DE LA CRUZ, SPANISH
Oops! Sorry, Wrong Door, 1604
Oil on canvas

GUSTAVE COURBET, FRENCH
Artist with Nude Model Who Couldn't Swing Day Care, 1855
Oil on canvas

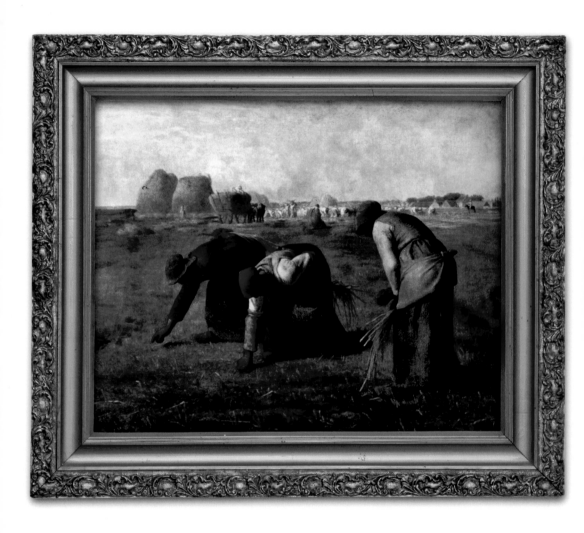

JEAN-FRANÇOIS MILLET, FRENCH

*Three Women Losing
Contact Lenses at Once*, 1857

Oil on canvas

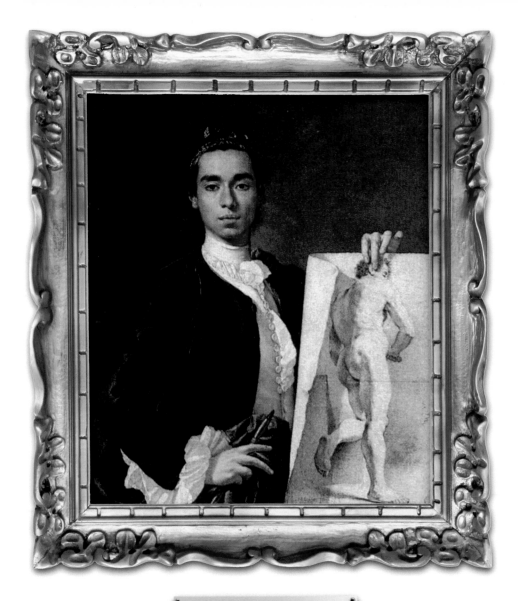

LUIS EGIDIO MELÉNDEZ, SPANISH
*Artist with Police Sketch of
Naked Dude Who Stole His Easel*,
1746
Oil on canvas

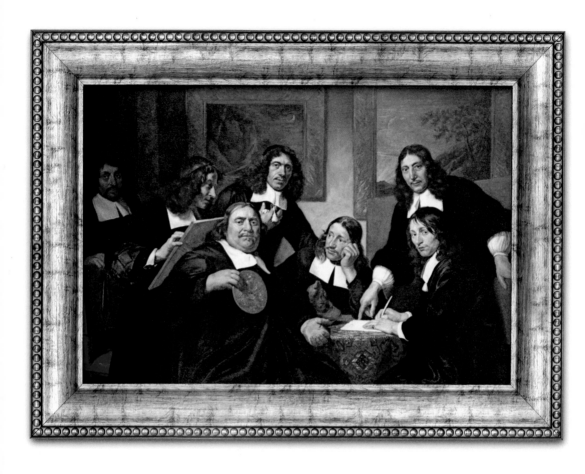

JAN DE BRAY, DUTCH

*Uh, Guys? How Long Has That
Painter Been Sitting There?*, 1577

Oil on canvas

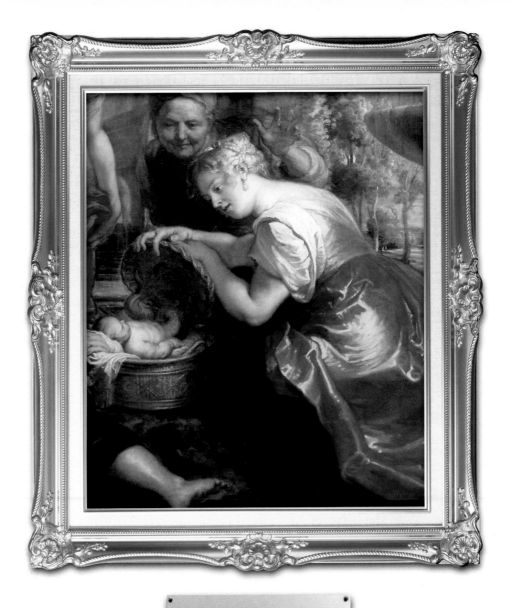

PETER PAUL RUBENS, FLEMISH
Worst Secret Santa Gift Ever, 1632
Oil on canvas

THE ART OF THE GAME

Sports

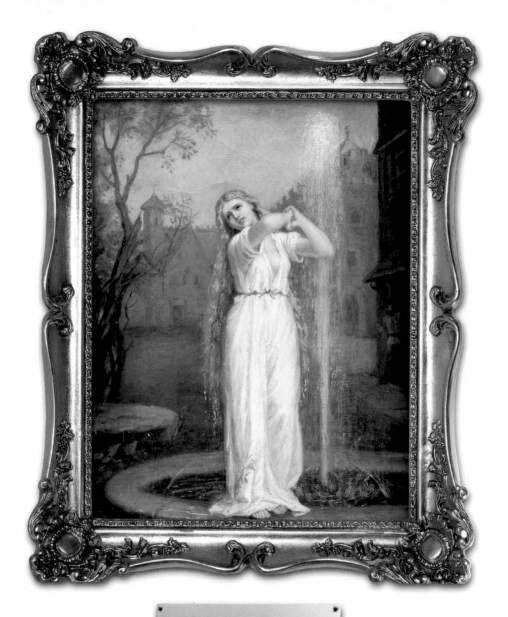

JOHN WILLIAM WATERHOUSE, ENGLISH

*Aphrodite Using Her 9-Iron
out of a Water Hazard*, 1872

Oil on canvas

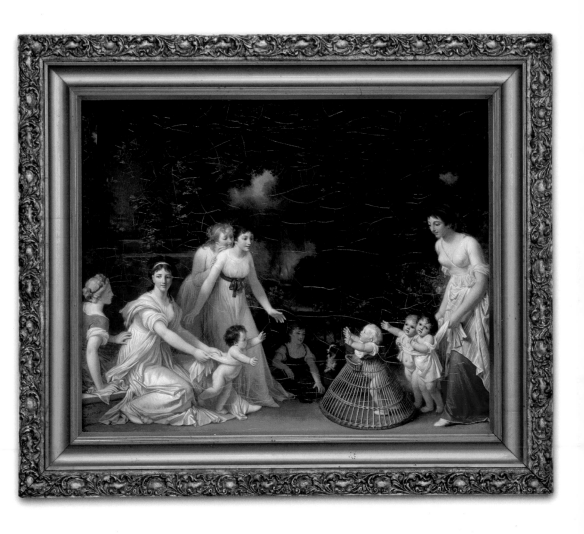

MARGUERITE GÉRARD, FRENCH
*Surveillance Video of Illegal
Baby-fighting Ring*, 1800
Oil on canvas

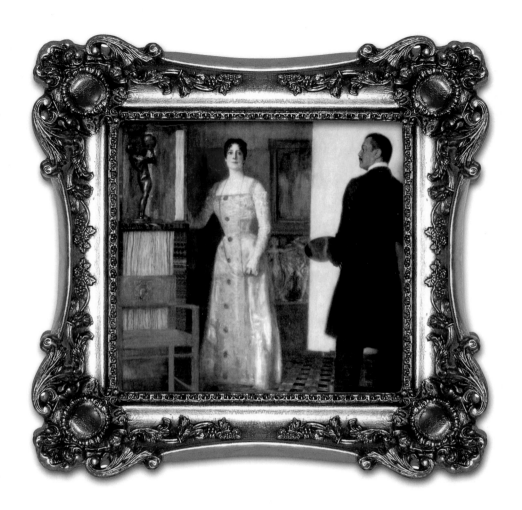

FRANZ VON STUCK, GERMAN

The Artist, His Wife, and His Bowling Trophy, 1902

Oil on canvas

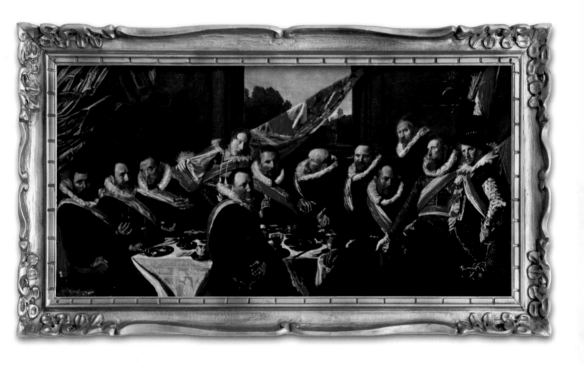

FRANS HALS, DUTCH

Precompetition Breakfast at the
Mr. Netherlands Pageant, 1616

Oil on canvas

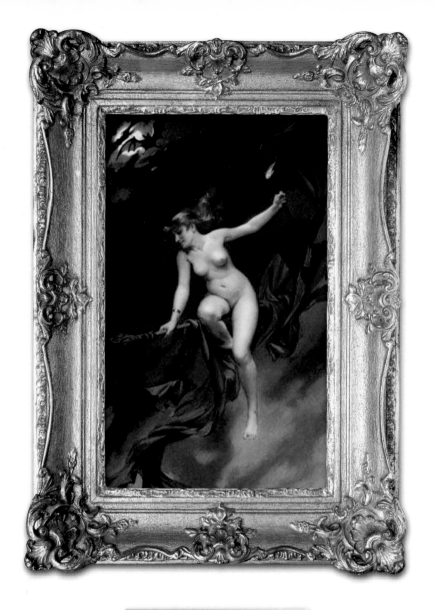

LUIS RICARDO FALERO, SPANISH
*Ginny Weasley Playing
Strip Quidditch*, 1896
Oil on canvas

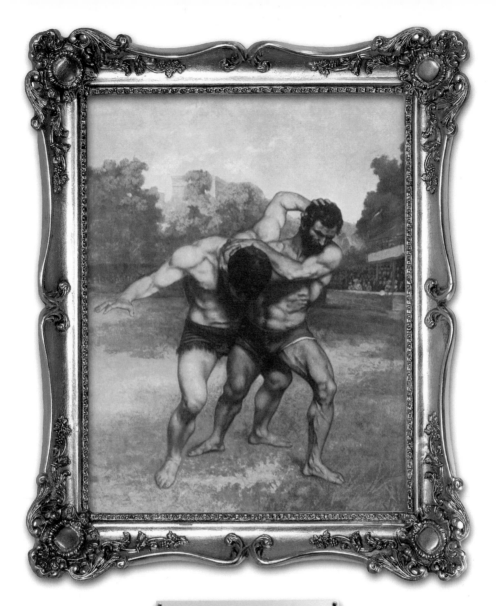

GUSTAVE COURBET, FRENCH

*Misunderstanding Over
a Jockstrap*, 1853

Oil on canvas

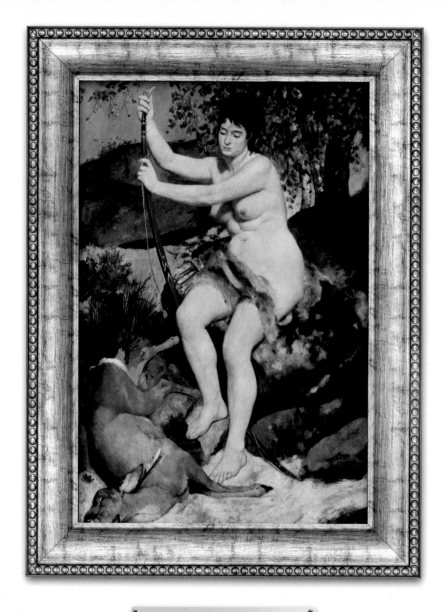

PIERRE-AUGUSTE RENOIR, FRENCH
*Kim Kardashian Bags
Her First Deer*, 1867
Oil on canvas

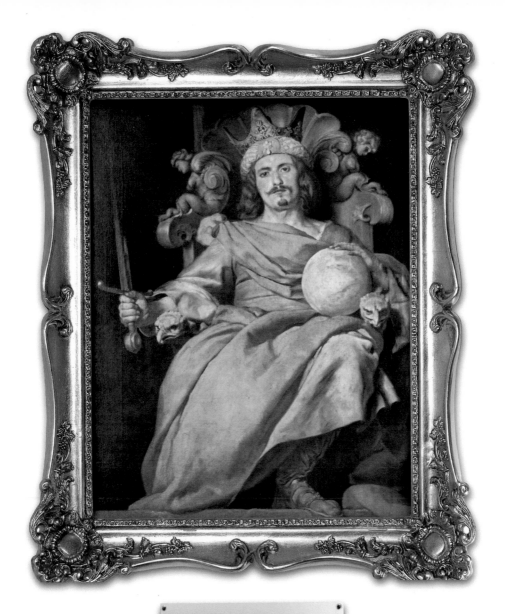

ALONSO CANO, SPANISH
League Night at Camelot Lanes,
1643
Oil on canvas

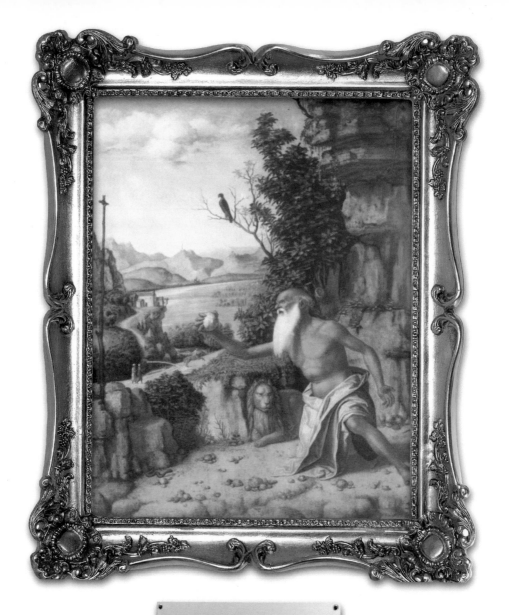

CIMA DA CONEGLIANO, ITALIAN
*Old Man Asking God to
Sign a Baseball*, 1492
Oil on panel

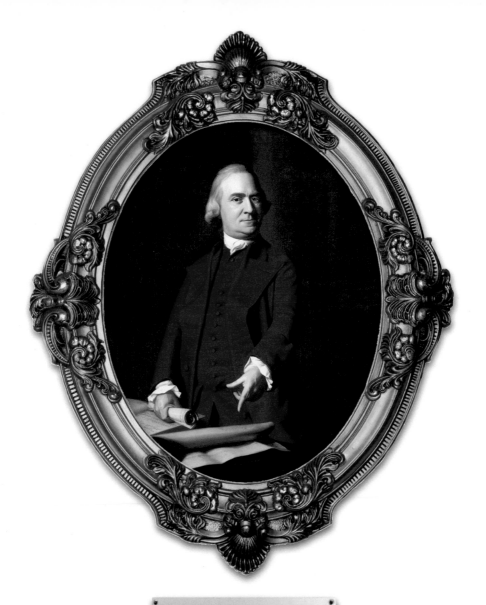

JOHN SINGLETON COPLEY, AMERICAN

*Samuel Adams Demanding to Know
Where His Sports Illustrated Swimsuit
Calendar Disappeared To, 1772*

Oil on canvas

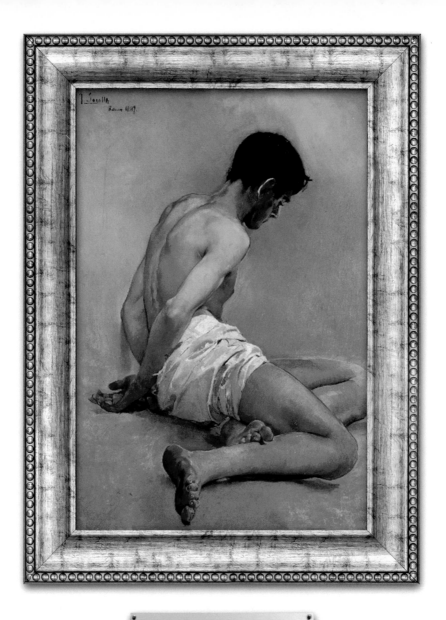

JOAQUÍN SOROLLA, SPANISH
*That Weird Guy at Yoga
I Was Telling You About*, 1887
Oil on canvas